AsiaTown Cleveland
From Tong Wars to Dim Sum

AsiaTown Cleveland
From Tong Wars to Dim Sum

ALAN F. DUTKA | *Foreword by Johnny Wu*

THE
History
PRESS

Published by The History Press
Charleston, SC 29403
www.historypress.net

Copyright © 2014 by Alan F. Dutka
All rights reserved

First published 2014

Manufactured in the United States

ISBN 978.1.62619.552.3

Library of Congress CIP data applied for.

Contents

Foreword

As an active member of Cleveland's Asian community, I was intrigued when Alan Dutka presented his idea to me of writing a book about Cleveland's AsiaTown neighborhood. I am the co-founder of the annual Cleveland Asian Festival, currently the vice-president of organizations and community relations for the OCA Cleveland Chapter (formerly known as the Organization of Chinese Americans of Greater Cleveland), the producer and co-host of an hour-long radio program promoting AsiaTown and its events and a board member of the St. Clair Superior Development Corporation, where AsiaTown is located. I am also an award-winning producer, director and editor for videos and events branding and marketing, and my company is located in AsiaTown as well.

Alan's book covers a lot of ground, from the first Chinese arriving in Cleveland in the 1870s to the current vibrant AsiaTown neighborhood. As his story progresses, he delves into how Asian culture and beliefs helped shape Cleveland's AsiaTown. The book is well researched, and Alan is a good storyteller. Even though I have a grasp of Asian history in Cleveland, I found many really fascinating stories and anecdotes that I had never heard before. I would recommend this book to anyone interested in Cleveland history, Asian history or how the current AsiaTown neighborhood was shaped.

Johnny Wu

Preface

Before reaching adulthood, I had no real appreciation for Chinese culture. As a ten-year-old, I didn't relish the egg foo young my mother would bring home from a Chinese restaurant located in the basement of the Hippodrome Theater. Growing up, I never realized a Chinatown even existed in Cleveland, believing these exotic places would be found only in New York, San Francisco or on sets used to film old Charlie Chan movies shown on late-night television in the pre–Jack Paar era.

Although eventually discovering the intriguing variety of foods offered in suburban Chinese restaurants, I never investigated Cleveland's Chinatown until 2006. Since I lived in downtown Cleveland and had just purchased a new camera, I amused myself by locating and photographing a group of fiberglass canine sculptures placed around the neighborhood to celebrate the year of the dog. Neighborhood promoters thought the colorful dogs might call attention to the region; in my case, their idea proved to be correct.

Not knowing what to expect in an unfamiliar neighborhood, I parked my car as close as possible to each of the twenty-five or so sculpture sites. The next year, I repeated the process, this time photographing pigs. As the years passed, statuettes of rats, oxen, tigers, rabbits, dragons and snakes graced the streets of AsiaTown, the rebranded name for the old Chinatown area. Continuing to take photographs, I realized I didn't have to drive to each site. The neighborhood, not only very walkable, is also distinctive, interesting and even friendly. These fiberglass-inspired expeditions aroused my curiosity about the history of the neighborhood

and its residents, shops and restaurants. This book represents my attempt to recount this history.

In order to not burden readers with street name changes occurring early in the twentieth century, all streets are referenced using their current names. Thus, Seneca Street, the location of the first concentrated Chinese settlement, is referred to as West Third Street, its current name. Also, references to proper Chinese names can be confusing since, for example, Wah Louie and Louie Wah refer to the same person, the difference explained by the specific time period and Mr. Wah's interest in adopting American customs. To the extent possible, I have employed the naming convention that each individual seemed to choose.

Acknowledgements

The following individuals provided significant contributions to this book:

CLEVELAND PUBLIC LIBRARY
Beverly Austin (history)
Margaret Baughman (photographs)
Nicholas Durda (photographs)
Thomas Edwards (history)
Patrice Hamiter (photographs)
Sabrina Rosario (history)

CLEVELAND STATE UNIVERSITY
William C. Barrow (Special Collections)
Lynn M. Duchez Bycko (Special Collections)

BUSINESSES/ORGANIZATIONS
James Amendola (St. Clair Superior Development Corporation)
Jaewon Chang (Miega Korean Barbeque)
Jung Chang (Miega Korean Barbeque)
Gary Chen (Park To Shop)
Michael Fleming (St. Clair Superior Development Corporation)
Steve Hom (Asia Plaza)
Cory Riordan (St. Clair Superior Development Corporation)
Siyan Wei (Siyan Dress)

Acknowledgements

Lisa Wong (Organization of Chinese Americans of Greater Cleveland)
Johnny Wu (Media Design Imaging)
Connie Zhang (Sister's Gift Shop)
Danny Zhang (Flower City Gift Shop)

INDIVIDUALS
Diane Dutka
Priscilla Dutka
Peter Haluszka
David Horan
Yin Tang

THE HISTORY PRESS
Greg Dumais
Jaime Muehl
Emily Kirby
Gracie Aghapour
Bob Barnett
Katie Parry

Introduction

As the nineteenth century ended, newspapers described Cleveland's diminutive Chinese community as "peculiar," "strange," "curious," "odd" and even "queer," while referring to the Chinese themselves as "almond-eyed celestials." The political incorrectness didn't foster harmonious relationships between the small number of Asians and the remainder of the city's population. Rumors conveying the existence of mysterious trapdoors, hidden passageways and decadent opium dens and gambling houses fascinated the mainstream population, which never became part of the closed, secretive and seemingly exotic Chinese society.

A handful of Chinese residents shaped a tentative community on West Third Street, followed by a more substantial neighborhood on Ontario Street, only to see the latter condemned and demolished. Rockwell Avenue, Chinatown's next locality, survived for sixty years before competition, crime and waning interest ended its reign.

In the twenty-first century, the city's growing AsiaTown community is viewed by many Clevelanders as hip and chic rather than as peculiar or strange. Coexisting with many nationalities in a racially diverse area, the neighborhood draws people from many parts of the city and surrounding suburbs. Chinese, Korean and Vietnamese restaurants cater to an expanding Asian population, while diners from vastly·different ethnic backgrounds have transformed these eateries into destination locations. Newly built malls house Asian restaurants, grocery stores and specialty shops. The once-secretive Asian community enthusiastically welcomes daily visitors, promotes

Introduction

its New Year celebrations and stages an annual two-day spring festival attracting more than forty thousand Greater Clevelanders. Meanwhile, the old Rockwell Avenue Chinatown is exhibiting noteworthy signs of revival.

The transition from Chinatown's first tentative presence on West Third Street to Cleveland's contemporary AsiaTown community shapes remarkable tales that span nearly one and a half centuries. Hard work, violence, education and prejudice all interacted as Asians sought to assimilate their distinctive and diverse cultures with that of their non-Asian neighbors.

Cleveland's Mysterious Colony

The Birth of Chinatown

In the mid-nineteenth century, dreams of securing a better life inspired hundreds of thousands of Chinese to leave their birthplace and immigrate to America's West Coast, virtually all arriving from four or five districts of Canton (Guangdong). Earning poor pay for long hours of strenuous work, these immigrants panned gold, helped build the Transcontinental Railroad or worked as domestic servants. The Chinese encountered fierce hostility from American workers, unions and politicians. Denis Kearney, an Irish-born labor leader in San Francisco, claimed a Chinese immigrant "brings with him all the loathsome and vicious habits of his native country." Kearney usually closed his passionate anti-Chinese speeches, sometimes lasting two hours, with the comment, "And whatever happens, the Chinese must go." California politicians publically proclaimed the "Oriental" race as inferior to Caucasians. Coinciding with the personal insults, California enacted discriminatory taxes on Chinese entering the state or working in mines.

The anti-Asian sentiment, coupled with declining employment opportunities as the gold rush faded and the railroad reached completion, inspired some Chinese to travel eastward in their continued search to improve their lives. A minute number of these West Coast exiles settled in Cleveland. The city's 1880 population breakdown grouped Chinese and Japanese residents into a single category. The consolidation didn't really matter; the combined groups totaled only 23 persons residing in the country's eleventh-largest metropolis, inhabited by 160,146 people. As the United States restricted immigration, Cleveland's Chinese population grew very slowly—

and for substantial periods, not at all. An immigration law enacted in 1882 prevented most Chinese women from entering the United States, even if their husbands already resided in the country. In 1900, Cleveland's Chinese colony, virtually a bachelor community, consisted of 86 males and 8 females.

Vast differences in language, customs, food, dress and physical appearance highlighted the dissimilarities between Chinese-born immigrants and native Clevelanders. An aura of mystery and, at times, prejudice quickly developed. Interracial marriage, an outgrowth of the heavily weighted Chinese male population, sparked intolerance among many Clevelanders. In 1884, Wan Lee Yew married Mary Chafer, an Irish woman; the couple celebrated their vows in both American and Chinese wedding ceremonies. As the two honored a Chinese custom by walking down the street where they were married, Clevelanders pelted the groom with stones while striking him with clubs; the bride suffered bruises from assaults while the pair attempted to peacefully stroll down Ontario Street. But Mary did not regret her choice, telling a *Plain Dealer* reporter, "A Chinaman makes twenty-five cents and gives it to his wife, while an Irishman would spend it for drink."

A small number of Chinese found employment in factories, but the majority owned or worked in laundries, restaurants, grocery stores or shops. The layout of a typical laundry consisted of an entrance where employees interacted with customers, an area dedicated to washing machines and sinks, a clothes-drying section and living quarters for the owner. Washing clothes consisted of soaking garments in boiling water and then firmly slapping them on a flat board, each slap usually accompanied by a grunt. Preparation for ironing began when a worker filled his mouth with water from a tea bowl. As he pressed his lips into a nozzle, a swift, strong puff created a spray of water used to dampen the clothes.

Unable to converse in English while many customers spoke no Chinese, laundrymen invented a unique system for keeping track of orders. Each claim check contained two characters; the first indicated the day of the week the laundry received the order, and the second represented an object, such as a dog, lion, table or house. The laundryman tore the check into two pieces and gave one part to the customer. When the patron returned to collect the clothes, an employee matched the two pieces to ensure the correctness of the order. The proprietor also entered the two characters in a store log, along with information regarding each article of clothing and a description of the customer, which might be his vocation or some physical characteristic. Fortunately, non-Chinese patrons could not translate these descriptions, which often contained comments such as "lady very fat" or "man looks like a horse."

Laundryman Hong Kee combined good looks, competence and a hint of mystery to gain favor with Cleveland society ladies. *Courtesy of the* Plain Dealer.

Against heavy odds, Hong Kee transformed himself into a celebrity washman. In search of riches in America, the handsome nineteen-year-old chose to leave behind a reasonably wealthy family life in China. In 1898, following a short stay in San Francisco, Kee opened a laundry on Euclid Avenue near Wade Park, an ideal location to service homes of the city's millionaires. Infatuated with the young entrepreneur, the avenue's society ladies invited him into their kitchens for tea, cake and pie. During the Christmas season, wives of wealthy industrialists showered him with costly gifts ranging from silk socks and satin table covers, embroidered in Asian fashion, to opal rings cast with diamonds. After a few very lucrative years in Cleveland, Kee returned to San Francisco with enough capital to launch an expansive laundry business.

In 1906, a laundry's weekly receipts of seventy-five dollars generated a profitable business, although the owner usually worked ten to sixteen hours daily, often seven days per week. His laborers, who manually washed, ironed and folded shirts, earned about eight dollars per week. After World War II, when many owners still used an abacus to balance their books, the laundries faded from existence as wash-and-wear fabrics and modern dry cleaning methods diminished the need for hand laundries.

By 1976, only a handful of Chinese laundries remained in Greater Cleveland. Rising costs accelerated their decline as smaller businesses incurred difficulties absorbing inflated expenses. In the laundry industry, the cost of the cardboard stuffing for laundered shirts rose from $5.75 per thousand to $18.00 in just a few years. Additionally, far more rewarding opportunities now existed for Chinese Americans.

Restaurant owners perpetuated traditional food preparation techniques that had existed in China for decades, if not centuries. Eateries emphasized Cantonese cooking since most Chinese had migrated from Canton. Straddling a bamboo pole, cooks rolled the shaft over dough used to make noodles. This time-honored flattening process created an unusual springy consistency. Following the flattening operation, cooks hung the sheets of dough on another bamboo pole, this one suspended from the ceiling. Chefs then cut the sheets into noodles of appropriate size.

The restaurants introduced chop suey to the city. The dish incorporated mushrooms, sweet potatoes, bamboo shoots, celery and the white meat of chicken and pork, all mixed with peanut oil and flavored with gin. But owners carefully guarded the actual recipes, accessible only to trusted chefs and carefully locked in safes at the end of the day.

The restaurants also housed showcases jammed with bracelets, slippers, teacups, bowls, fans and trinkets. The owners and staff labored long hours, as

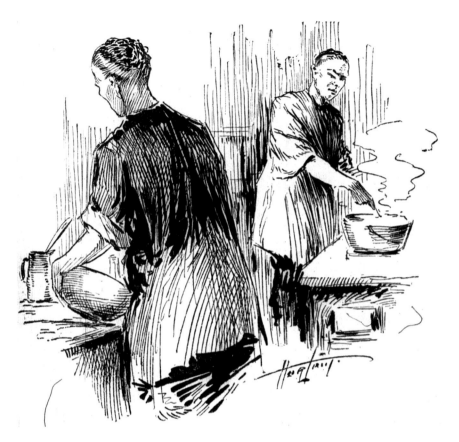

At the turn of the twentieth century, Chinese restaurants catered to the local Chinese population; only a limited number of adventurous native Clevelanders patronized the eateries. *Courtesy of the* Plain Dealer.

eateries remained in operation until about 3:00 a.m. and then reopened four hours later for breakfast. Cooks received fifteen dollars per week, while waiters earned ten dollars. By 1900, the presence of telephones and cash registers demonstrated America's growing influence on the Chinese way of life.

Even though chop suey remained in style, Chin You introduced *qua tasse* (a dish seldom cooked outside of China) in his East Ninth Street restaurant. An ensuing incident proved to be life threatening to You, but not because of the food's ingredients or his clients' hesitancy to experiment with a new menu offering. Ga Dow, the restaurant's cook, deeply resented the owner's interference in his preparation of the unusual dish. As forty panicked patrons fled into the street, You and Dow fought for possession of a revolver the cook had drawn. After a verbal exchange,

In 1927, the Wah Chong Tie & Company store remained one of the most successful Chinatown businesses. *Courtesy of Special Collections, Michael Schwartz Library, Cleveland State University.*

Dow shot You in his right hip. With the gun still in his hand, Dow stood over his anguished employer until police arrived. Apparently abandoning his surrender plan at the last minute, Dow fled up East Ninth Street, but an officer easily apprehended him. In explaining the fracas, Dow told police that the restaurant owner had shouted at him, "*Qa sia dan quo mak*

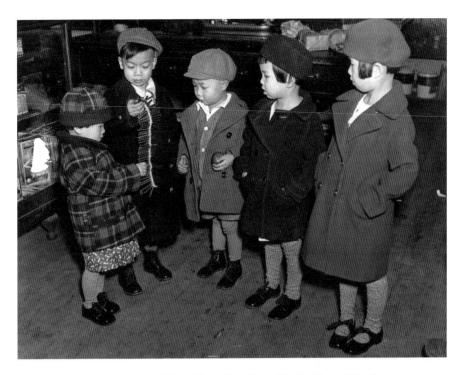

Youthful patrons Young Louie, Kong Chan, Pay Chan, Yau Louie and Kan Louie investigated merchandise in an Ontario Street store. This photograph is from 1927. *Courtesy of Special Collections, Michael Schwartz Library, Cleveland State University.*

dest san!" which a helpful bystander loosely translated as "You are the worst excuse for a cook that ever existed!"

Chinese shops, resembling American country stores, stocked a little bit of almost everything. Their shelves contained sugarcane, nuts, boxes of roots used in cooking and cans of bamboo sprouts and plums. Dishes, platters and tea chests sat crammed against straw slippers, authentic Chinese shoes, bits of embroidery, fans and bracelets ranging from cheap imitations to real jade. The artificial jade bracelets sold for a quarter; the genuine Chinese shoes commanded four dollars a pair. Wah Chong Tie & Company sold ginger displayed in earthen jars, bottles of poppy seed oil, vinegar made from black rice, choy sauce using the juice of oysters and penny candy for children.

In the 1890s, Chinese operated businesses and lived in homes throughout downtown Cleveland. Caucasian landlords coveted Chinese tenants who paid their rent without incident and seldom complained. Concerned with working hard and saving money, Chinese paid reasonably high rent for sometimes-rundown quarters without demanding many improvements or repairs.

On West Third Street near Lake Erie, the Chinese Masonic Lodge converted a once aristocratic but later dilapidated three-story residence into its headquarters building. Chinese stores filled the street-level space; a boardinghouse made use of the entire second floor. The third-floor Masonic headquarters integrated office space, meeting rooms and a temple. Rather than a political or religious organization, the Chinese lodge functioned primarily as a social club. But a visitor needed a secret codeword, changed every thirty days, to gain entrance to the second or third floors.

The Cleveland Chinese community's first appearance in the national spotlight came about when Peter Len Ling launched his Woodland Avenue temple. In 1891, the Grand Lodge of the American Chinese Free Masons selected the remodeled former home to host its national meeting, which took place only once every five years. Local Chinese leaders realized they needed something special for their small group to make a positive impression on national leaders who had conducted their last meeting in San Francisco's Chinatown. Gathering together their seventeen foremost musicians, the community organized a temporary orchestra to play sacred compositions at the meeting. But their diligent practice sessions ended abruptly when police, acting in response to neighborhood complaints, arrested and jailed the entire orchestra for creating distracting noises. Freed on bail, the group performed admirably at the event and then disbanded.

Very little interaction existed between Chinese and native Clevelanders. Yet in 1891, a drunken Wau Kee, the proprietor of a West Third Street laundry, announced to a saloon crowd that white people had no right to remain alive. The saloon's patrons quickly departed as Kee produced a meat cleaver, pledging to do his part to exterminate Caucasians. Shortly afterward, a police officer smashed a chair over Kee's head before sending him off to jail. Although he suffered a three-inch gash to the head, Kee wanted no part of medical treatment for fear of ruining his queue (cue). Five men restrained Kee as a doctor carefully attended to the wound without destroying Kee's pigtail.

In 1900, the *Cleveland Leader* praised the city's Chinese residents for their resourcefulness and work ethic. Yet, consistent with mainstream turn-of-the-century attitudes toward Chinese, even the most well-intended compliment conveyed a backhanded message; the newspaper began its accolade by stating, "To the average person, the Chinaman will always appear to be the same dull, queer, and undemonstrative creature that he was when he first entered the country long ago."

Although the Chinese community sustained its shroud of mystery, in reality, many members lived in miserable squalor. Amongst humble restaurants, crowded shops, infamous opium dens and makeshift gambling houses, Chinese resided in flimsy and often dilapidated residences, coexisting with roaches and rats while being plagued by poor sanitation in gloomy rooms typified by creaking stairs.

Although hardworking and law abiding, local Chinese endured a difficult and sometimes violent existence. On the morning of October 8, 1901, the usually punctual Sing Ki failed to open his East Ninth Street restaurant. His bartender, armed with a hatchet, broke down the door to Ki's apartment above the eatery. He discovered Ki lying in a pool of blood; a razor slash to his throat, extending from ear to ear, had nearly detached Ki's head from the remainder of his body. The previous evening, Ki had quarreled with Anna Fahey, a waitress in his restaurant. He supposedly assaulted her and threatened to kill her. Although the coroner ruled that Ki had committed suicide because of his dishonorable behavior, the community suspected highbinders had executed a sinister murder.

Highbinders, originally residing on China's mainland, visited Chinese business owners in the United States on an annual basis. In anticipation of the visits, entrepreneurs received bright red pieces of paper, delivered by mail, announcing the date and arrival time of the highbinder, along with a specified amount of extortion money, which the highbinder expected to receive. The thugs demanded a payment averaging twenty-five dollars from Cleveland enterprises. Not honoring the request, or informing the police, could result in repercussions back in China, typically physical harm to relatives remaining in their homeland, the burning of a productive rice field or the slaughter of a prize cow. In addition to creating emotional trauma by threatening crimes against family members residing seven thousand miles from Cleveland, the highbinders faced less chance of prosecution in the United States than in China. Refusal to pay shakedown money for a prolonged period could trigger a merchant's murder, a likely cause of Sing Ki's death.

Not agreeing with the coroner's conclusion, three local Chinese leaders (Yee Hing, Wah Chung Tai and Quong Hop) spearheaded their own investigation. Under the heading "Reward for Murder of Sing Ki," Cleveland newspapers carried this message: "Whereas Sing Ki was murdered at 101 Erie [East Ninth] Street about October 8th, 1901, we hereby offer to pay for the arrest and conviction of the person or persons who committed said crime the sum of three hundred dollars." Neither the police nor the Chinese apprehended the murderers.

Ki's family chose an expensive satin-lined, silver-handled coffin made of heavy sandalwood. According to their belief, a more expensive coffin incurred a better chance of delivering Ki to the next world. Along with Ki's body, a chicken placed in the coffin supposedly assisted him on his spiritual travels, while a silver quarter positioned in Ki's mouth paid his ferry expense across the river to the other world. A mirror, according to tradition, helped Ki locate his assailant in the next world. A large and finely sharpened knife provided assistance to Ki in his eventual altercation with his killer. The knife would either help avenge his death or protect him from a second attack.

At the time, nearly all funeral processions included a ritual whereby mourners tossed small pieces of red or yellow paper, each containing a Chinese prayer, into the air. The Chinese sought to distract any devils intending to follow the body to the cemetery. Grieving Chinese sometimes punched holes in the paper, believing this would further disrupt evil spirits. Despite adherence to ancient customs, Ki's funeral revealed an increasing Americanization of the Chinese community as younger Chinese, dressed in the latest American-style clothing, clashed with members of older generations, clad in traditional Chinese robes.

Into the early part of the twentieth century, Chinese considered Cleveland's burial grounds only provisional resting places until their remains could be sent back to China for permanent interment. Without returning to their native land, the Chinese believed their souls would be subjected to eternal damnation by remaining at rest in Cleveland. In 1909, the Chinese Masons organization paid the shipping charges for the remains of seventeen Chinese, buried in Woodland Cemetery, to be sent to their homeland. The bones of individual persons, each placed in their own box about nine inches in height, joined those from other cities for shipment to San Francisco. There, a large funeral ship transported the boxes to Hong Kong. Relatives claimed the remains for burial in suitable Chinese graves.

The temporary Chinese Exclusion Act, initiated in 1882, severely restricted immigration to the United States. In 1902, when the government made the law permanent, federal officials soon began a crackdown on Chinese in America, planning to deport residents lacking proper papers. Despite Cleveland's small Chinese community, or perhaps because of its size, the government allegedly targeted the city for its initial investigations. Chinese across the country developed a unified network to protect the rights of Chinese residing in the United States. The government responded by becoming less active in its deportation activities.

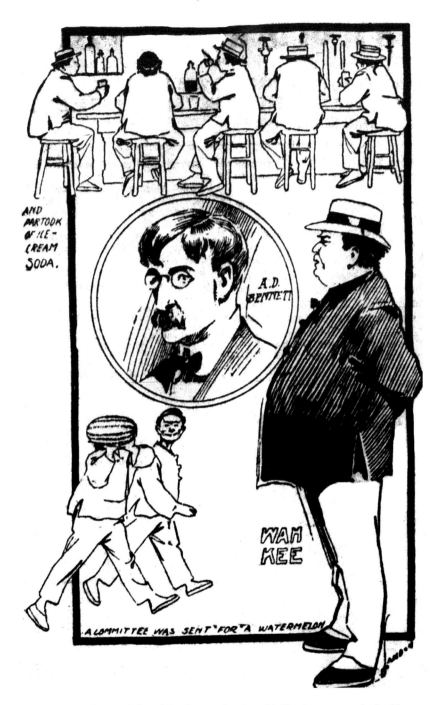

This schematic illustrated the origin of stomach aches: drinking ice cream sodas (top) in a drugstore operated by A.D. Bennett (center) and consuming a watermelon (below left) at a restaurant owned by Wong Kee (below right). *Courtesy of the* Plain Dealer.

In 1898, a failed political reform movement in China ended in a bloody coup. But cities throughout the world established branches of an organization dedicated to keeping these reform ideas alive. The ninety-member Cleveland offshoot discussed circumstances in China during meetings in a Hamilton Street office building around the corner from Ontario Street. Following one of these gatherings in 1904, twelve members decided to savor their very first ice cream sodas at A.D. Bennett's drugstore, located on the street level of the same building. Continuing their adventure, the group purchased a watermelon and proceeded to a backroom in Wong Kee's Ontario Street restaurant to carve and devour the tasty treat. The combined sodas and watermelon created another new experience for the daring dozen: their first American stomach aches.

Eight years later, another offbeat opportunity to advance cultural assimilation presented itself. While locked in the county jail, Yee Kim and Yee Yet tasted their first meal of sauerkraut and wieners. Their rave reviews of this dining delight inspired local Chinese to grow cabbages in their gardens.

In the twentieth century, access to medical care became more available. In 1904, Quong Hop, proprietor of an Ontario Street grocery store, and his wife celebrated the birth of their son. A great feast followed a cricket fight staged in the infant's honor. But the two-week-old baby continued a marathon crying spell that severely dampened the festivities. Local Chinese leader Wong Kee performed a special healing ceremony consisting of igniting his opium pipe with a substance that created a red flame in the hope of obtaining assistance from the god of luck. But the child continued to cry. In desperation, Hop summoned an American doctor who diagnosed the baby as suffering from colic. After the infant consumed two tablespoons of an unknown substance, his crying quickly stopped as he engaged in a restful sleep. Despite this success, few Chinese trusted Caucasian doctors.

Chinese doctors from New York and Chicago made three or four visits each year to treat the ills of local Chinese who generally refused treatment from American doctors. Bringing bags of herbs and concoctions in bottles, the doctors received payment only if their patients' health improved.

In 1907, Dr. Wang Loo, Cleveland's first permanent Chinese doctor, hung his shingle above a Lakeside Avenue grocery store. The doctor's first patient believed seven devils fighting within him had created severe shaking. Furthermore, the devils built fires that heated his body and caused him to burn. Dr. Loo prescribed a pill concocted from forty different herbs and the powdered bone of a ferocious Newchwang tiger. The pill worked perfectly since the herb's ability to alleviate fever had been known to Chinese for

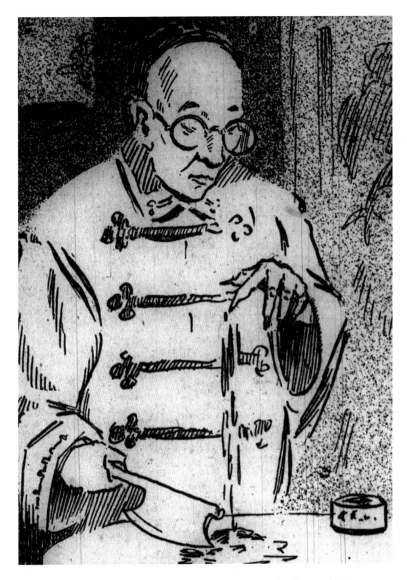

Dr. Loo, Cleveland's first Chinese doctor, in 1907, mixed one of his
mysterious blends that often produced positive results for his patients.
Courtesy of the Plain Dealer.

centuries. The usefulness of the tiger bone proved more difficult to verify,
but devils supposedly possessed a great fear of tigers.

An intestinal specialist, Dr. Loo recommended powder prepared from the
horns of a spotted rhinoceros as a cure-all for intestinal disorders. Liver

illness required consuming dried tiger liver ground into a powder, while treatment of rheumatism involved spreading an ointment containing cobra tail oil imported from India.

As the twentieth century's first decade ended, about 225 Chinese resided in Cleveland, although computing exact headcounts and rudimentary demographic information challenged census takers. The quality of the information hinged on cooperation from the residents, the skill of interpreters and the perseverance of the interviewers. Although Hop Louis fully cooperated with the census undertaking, the fact that his birth year occurred in the third moon of the dynasty of the Blue Prince of Peking proved problematic in pinpointing his age. Louis's actual birth date will never be known because all residents of China celebrated their birthdays on the same day: Chinese New Year.

In 1911, Ontario Street, between St. Clair and Lakeside Avenues, developed into the focal point for Cleveland's first Chinatown when two rival Chinese societies, the On Leong Tong and Hip Sing Tong, established their headquarters almost next door to each other on the street. Supposedly fraternal organizations, their interests at that time allegedly extended into gambling, prostitution, drugs, extortion and murder.

The Hip Sing Tong contemplated transferring its national headquarters from San Francisco to Cleveland. The members reasoned that Ohio must be the nation's most important state since it had sent the most number of presidents to the White House, and Cleveland reigned as the largest city in the country's foremost state. The relocation never took place, as San Francisco and New York remained the Hip Sing's most influential cities.

The On Leong Tong, a merchant association, temporarily resided in a building also accommodating a restaurant, grocery store and rented rooms. Elder statesman Lee Foo lived in one of the dingy backrooms, which he called the Lily Garden of the Seven Butterflies.

On March 29, 1913, silk-robed Chinese priests, assisted by drums, gongs, cymbals, string instruments and firecrackers, dedicated a new On Leong temple just a few storefronts south of the temporary quarters. Members from New York, San Francisco, Chicago, Seattle, Boston, Philadelphia, Cincinnati and Pittsburgh joined the ceremony and remained for a three-day national convention. Discussions focused on financial conditions in China and optimizing methods for shipping and transporting imported and exported products.

Meanwhile, prayers and the burning of small red paper devils helped the Hip Sing Tong commemorate its relocation to Ontario Street from temporary quarters on St. Clair Avenue above a saloon. The tong shared

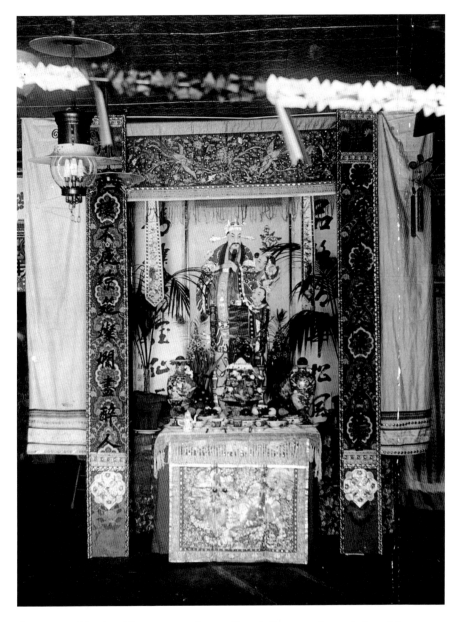

Chinese worshiped at this temporary altar on Ontario Street until completion of the new On Leong Tong headquarters. *Courtesy of Cleveland Public Library, Photograph Collection.*

its new space with Hop Len Weh & Company, an importing business, in a structure known as the House of the Bow-Legged Cat. Primarily a labor organization, the initial stated objectives of the Hip Sing involved promoting

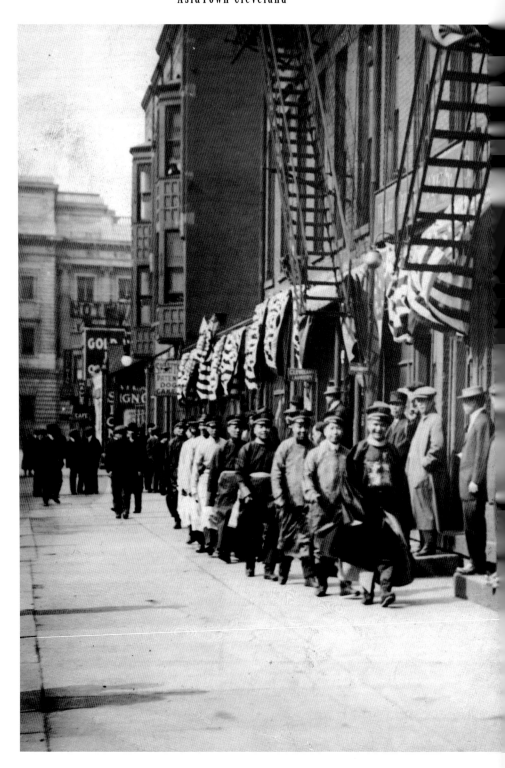

A 1913 parade honored both the opening of the new On Leong Tong building on Ontario Street and the organization's national convention. *Courtesy of Cleveland Public Library, Photograph Collection.*

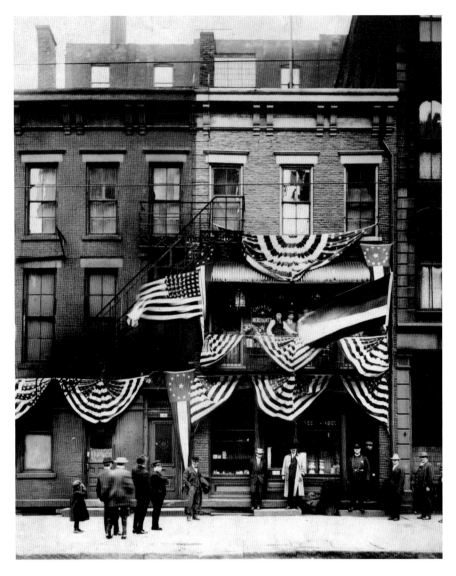

Flags flying from the new On Leong Tong headquarters helped welcome convention members from across the country. *Courtesy of Cleveland Public Library, Photograph Collection.*

a fraternal feeling among its members and monitoring and improving their working conditions. The tong recruited 50 of Cleveland's approximately 250 Chinese residents.

Even prior to the arrival of any significant number of Chinese in Cleveland, a few of the city's younger residents opted to serve as missionaries in China.

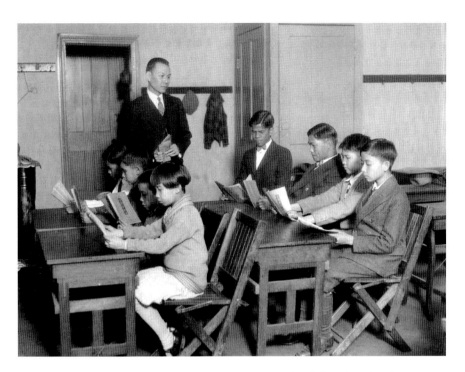

Peter Wong's Ontario Street school represents an example of the educational alternatives undertaken in the 1920s. *Courtesy of Special Collections, Michael Schwartz Library, Cleveland State University.*

Cleveland also supported the work of several missionary organizations located in China. In 1876, typical of Clevelanders' support, an Oriental bazaar held in Cleveland's First Methodist Episcopalian Church generated funds earmarked for the Kiu Klang hospital in China.

From their first settlement in Cleveland, Chinese encouraged education and cultural assimilation, although mostly for their offspring. But both children and adults participated in English reading and arithmetic classes held in various locations on or near Ontario and East Ninth Streets. One school relocated to the Cleveland Public Rockwell School, the later site of the still-existing Board of Education Building, now a hotel.

The Old Stone Church developed a legacy of service to the Chinese community, both as a place of worship and as a meeting space. In 1877, Reverend B.F. Shuart established a Chinese Christian Sunday school in his home. As participation increased, the school relocated to a church parlor and then to a chapel. Using a reader with Chinese symbols on one side and English letters on the other, adults and children learned the

33

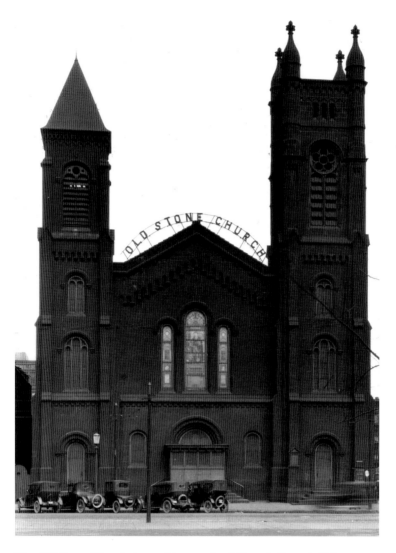

The Old Stone Church, located just south of Ontario Street's Chinatown district, participated heavily in Chinese education and cultural assimilation. This photograph is from 1920. *Courtesy of Cleveland Public Library, Photograph Collection.*

English language. The church introduced Bible study sessions following the students' mastery of rudimentary portions of the English language.

In the early twentieth century, the Old Stone Church served as an informal training school for prospective missionaries to China. In 1912, Chinese gathered at the church to celebrate the founding of the new Chinese

Republic. That same year, Harvey Meldrum Shung, the first Cleveland Chinese baby to be baptized into the Christian faith, received the sacrament at the Old Stone Church. In 1915, Chinese met to discuss the possibility of war between China and Japan. The meeting, attended by about five hundred Chinese, attracted participants from across the state.

Through the years, numerous Chinese weddings and funerals have taken place at the church. Woo Chong, who had spent most of his thirty-two years in Cleveland as an Ontario Street merchant, died in 1916. His Christian burial service at the Old Stone Church preceded a procession to Woodland Cemetery. Demonstrating Chong's three decades of Americanization, his burial incorporated no prayer papers or other Chinese rituals. Even into the 1970s, Chinese conducted a Christian service on Sunday afternoons at the Old Stone Church.

Following the end of the Chinese Revolution in 1912, younger Chinese broke with tradition to adopt American fashions. Youthful Chinese exchanged their queue hairstyles, distinguished by long hair gathered in a pigtail, for twenty-five-cent haircuts. Fashionable American shoes and trousers replaced customary Chinese clothing.

On February 14, 1913, Rose Livingston arrived in Cleveland to conduct ministry work. As newspapers dramatized human trafficking tales and silent films sensationalized the same theme, Livingston shocked Clevelanders by claiming fifty-five local girls had been sold into white slavery. Not everyone agreed with her assessment, but few disputed her personal life of trauma. Abducted at the age of ten from her Hamilton, Ohio home, she lived a forced life as a prostitute and opium addict in New York's Chinatown. She gave birth to two children, the first at the age of twelve and the second three years later. Rescued in 1903, Livingston dedicated her life to freeing young girls forced into white slavery in the nation's Chinatowns. Known as the "Angel of Chinatown," a Brooklyn, New York church paid her rent and provided her with a $1.50 weekly allowance.

Following a presentation at the Euclid Avenue Methodist Church, the father of a missing eight-year-old child approached Livingston for assistance in searching for his daughter. A few months later, Livingston's network of contacts located the child in Philadelphia and rescued her. During one of Livingston's presentations, a Chagrin Falls minister placed his gold watch in a collection plate. After his wife donated her diamond ring, members of the congregation contributed large sums of money to further Livingston's cause. During her reform career, the five-foot-tall Livingston suffered broken ribs

and legs while surviving stabbings, beatings, shootings and being thrown from a second-floor window.

By the 1920s, Chinese children, fully integrated into American culture, participated in an almost reverse educational curriculum. In a room above

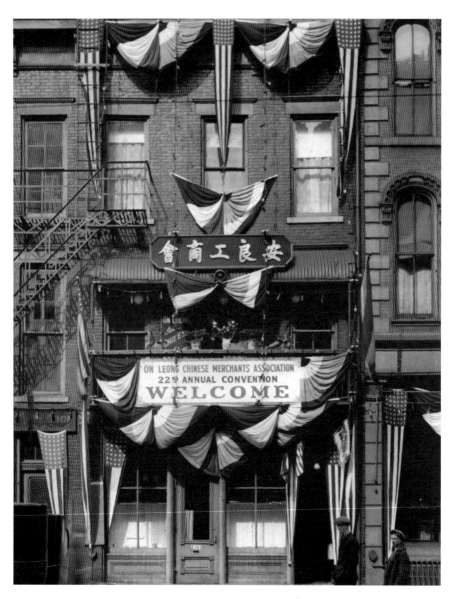

In 1926, the On Leong Tong building welcomed the organization's twenty-second national convention. *Courtesy of Cleveland Public Library, Photograph Collection.*

Jessie Wong's Ontario Street restaurant, about twenty-five Chinese children, four to twelve years in age, attended classes in reading and writing Chinese, along with lectures regarding Chinese culture, literature and history. In addition, education for parents of assimilated children dealt with difficult cultural issues, such as intermarriage.

In 1925, the Hip Sing Tong held its national convention in Cleveland with an objective to develop methods to teach its national members how to do business while adhering to American laws and business practices. The national On Leong delegation returned in 1926 to prematurely celebrate apparent peace between the two tongs. Famous national chefs prepared banquets, while the Chinese Symphony Orchestra of Chicago performed during the three-week convention.

As brutal tong murders expanded in the 1920s, city officials threatened to condemn and demolish the decaying structures that composed Ontario Street's Chinese community. In 1930, as odors of dried fish, tea, chop suey

In 1929, developers razed all of the buildings composing the Ontario Street Chinatown for the construction of a new U.S. Parcel Post Building. *Courtesy of Special Collections, Michael Schwartz Library, Cleveland State University.*

and soap still permeated the street, Cleveland leaders carried out their warnings by razing the Chinatown neighborhood to make way for a United States Parcel Post Building. A fragment of the Chinese community relocated their homes and businesses to East Fifty-fifth Street. The On Leong Tong built a new headquarters on Rockwell Avenue; most of the Ontario Street community followed the organization, in the process creating a new Chinatown. A Chinese presence still exists on this segment of Rockwell Avenue. The east side of the old Ontario Street Chinatown now houses the Global Center for Health Innovation and the soon-to-be-built convention center hotel. The eastern end of the Justice Center occupies the west side of Ontario Street.

2
Chinese Boss Men

Movers, Shakers and Gamblers

In the 1870s, Chong Lee and Wau Kay, two competing laundrymen, often clashed as they vied to become "the boss man of Cleveland." Lee, a naturalized citizen and respected businessman, owned laundries on St. Clair Avenue and Public Square. Possessing a good command of the English language, he dressed in American-style clothing and married a German by the name of Lizzie, although the two later divorced due to her unfaithfulness. Also owning a St. Clair Avenue laundry, Kay gained more recognition as the proprietor of a West Third Street gambling house. Clad in traditional Chinese garments, he earned much of his wealth by extorting money from the community.

A conflict between Lee and Kay vividly illustrates the hurdles American courts encountered while enforcing laws in the Chinese society. Although the pair rarely spoke to each other, their mutual enjoyment of betting united them on one ill-fated evening when Kay invited Lee to his gambling den. The following morning, Lee accused Kay of getting him so drunk that he didn't realize Kay had robbed him of ninety dollars. At the ensuing trial, the judge could not locate neutral interpreters within the community. A pair of translators, each representing one of the opposing sides, frequently disputed the other's interpretations of the testimony. The arguments became commonplace enough to cause one individual to fall asleep on the witness stand. Another prosecution witness, not familiar with rules of etiquette governing American legal systems, shouted profanities and obscenities at the defendant's attorney. The judge, unable to believe the testimony of either side, cited lack of evidence in dismissing the case.

As Clevelanders gained an interest in Chinese restaurants, Wong Kee incorporated both Chinese and English versions of his signature on the front cover of his menus. *Courtesy of the Plain Dealer.*

Although neither Wau Kay nor Chong Lee succeeded in dominating the local Chinese scene, a few Chinese did rise to unofficial positions as pillars of their community. These leaders often walked a fine line between respectability and criminal activity.

Wong Kee arrived from the West Coast in 1896. In addition to a lucrative career as a partner in the Wah Chong Tie merchandise store, he owned a chop suey restaurant on West Third Street near one of the first concentrations of local Chinese activity. In the early twentieth century, Kee relocated his restaurant to Ontario Street and, in addition, operated the Golden Dragon Restaurant on the west side of Public Square. Dr. Sun Yat-Sen, the revolutionary who founded the Chinese Republic, visited the Golden Dragon to raise funds in support of his opposition to the Manchu Dynasty. Kee also owned the elaborate Hong Kong Low (translated Swell Cash) Restaurant on East Ninth Street near Chester Avenue. Seeking to acquire wealth while maintaining the integrity of Chinese cooking, Kee created an informal chop suey trust by purchasing competing restaurants and carefully guarding secret recipes known only to himself and his most trustworthy cooks.

Pittsburgh salesman E.W. Long did not share Kee's enthusiasm for the clandestine chop suey recipes, supposedly handed down from father to son for thirty centuries. In 1905, Long ordered a bowl of chop suey at Key's Hong Kong Low Restaurant but refused to pay the bill, doubting the dinner's authenticity. A passing policeman arrested Long as he punched three of the restaurant's employees in their faces, blackening their eyes and bruising their noses. Long incurred a fine of one dollar plus court costs.

On June 24, 1900, Kee's wife gave birth to a daughter, the first full-blooded Chinese baby born in Cleveland. Eight years later, Kee's wife and three children returned to China for a ten-year stay to ensure that the rapidly Americanizing children received a proper education in Chinese traditions, culture and religion. Jessie, one of the children, returned to Cleveland to become a leading Chinese restaurant owner.

Wong Chung, Kee's brother, purchased food and supplies for his own restaurant, all of Wong Kee's establishments and most of Cleveland's remaining Chinese restaurants. On a daily basis, he procured about one hundred chickens, one hundred pounds of meat, twenty-five pounds of butter, ten dozen eggs and a large quantity of vegetables. If Chung considered a market vendor's asking price excessive, he moved on without any attempt at negotiation. Wong Shee, another brother, enjoyed in St. Louis's Chinatown the same success and status as Wong Kee did in Cleveland.

Partly through his presidency of the local Chinese Masons, Wong Kee rose in prominence to become the city's first influential Chinese leader. Newspaper reporters referred to Kee as the "prince of Cleveland's Chinatown," "czar of Cleveland Chinese" and "king of the Cleveland colony." When a countryman became embroiled in trouble, Kee provided a lawyer. If a Chinese person ended up in a jail cell, Kee paid the bail. When an entrepreneur required a loan, Kee supplied the money. His territorial reign extended east to the border of Erie, Pennsylvania, south to Cincinnati and west to Detroit's border. A skilled negotiator, Wong Kee rarely finished second best in business dealings. Yet when an installer delivered Kee's first telephone, he rigged the device to disconnect as soon as a conversation started. The telephone worker told Kee he had harmed the equipment by speaking Chinese into an American machine. An extra payment of five dollars would be necessary to convert the telephone into the Chinese language. Kee gladly paid the additional money.

By 1907, Wong Kee had relinquished some of his power as rivals migrated to Cleveland. At the end of the decade, three competing tongs vied for power. Wong Kee presided over the Wong Tong, headquartered in his Hong Kong Low Restaurant. The Chan Tong operated in a Chinese restaurant on Prospect Avenue opposite the still-existing Colonial Hotel. The Lee Tong resided on East Sixth Street opposite the Hollenden Hotel. The tongs' intense business and political rivalries prohibited members of opposing groups from even attending night school classes together. Although challenged by others, Kee continued as a powerful influence in Cleveland's Chinese community. In 1947, Kee died in the city at the age of eighty-five.

Yee Hing, another early leader, lived above his Lakeside Avenue tea and grocery store. One of the wealthiest Chinese persons in the country, Hing used his prosperity and business success to expand his local influence by granting business and personal loans. In 1902, with Chinese women in short supply, Hing dispatched his nephew to San Francisco to uncover and purchase a suitable bride. Long before reaching the West Coast, the nephew purchased Ching Lee, a Manchurian slave girl, for $500 from

Ching Lee, the beautiful but tragic bride of Yee Hing, suffered from mental disorders aggravated by her isolation within Cleveland's Chinatown. *Courtesy of the* Plain Dealer.

Chinese Jake, the matchmaker of Chicago's Chinatown.

Prior to the arrival of his future wife, Hing invited his Cleveland cronies to a celebration in his store. Police raided the party and arrested the entire group, except for Hing, on gambling charges. Just before the officers arrived, Hing supposedly left the merriment to stare at the stars and meditate on his coming marriage.

The bride arrived in Cleveland with her face covered with crimson veils and wearing a dress highlighted with handcrafted embroidered silk. Gazing at his new bride for the first time, Hing reportedly passed out, apparently overwhelmed by his pleasant surprise. Ever the businessperson, Hing estimated her dress alone cost $200, thus substantially reducing the $500 matchmaker fee he paid. The wedding publicity also generated a sizeable increase in his tea business as native Clevelanders joined Chinese in their curiosity regarding the newly married couple. But Hing never recapped his total investment in Ching Lee, which included a $10,000 dowry payment to the bride's parents.

Consistent with Chinese custom, Lee had already taken her wedding vows in Chicago, and Hing in Cleveland, even before the two ever met. The Cleveland wedding, administered to both parties at the same time, satisfied American law and provided the motivation for a huge Chinese celebration. During the ceremony, Hing's marriage instructions seemed to lack the customary American romanticism: "She will cook for you the chop suey, wash for you the silk stockings. Feed her with rice. Be good to her."

Ching Lee remained isolated from her husband's business acquaintances and had no interaction with other Chinese women in a city nearly devoid of Asian women. She entered into ongoing treatment at Deaconess Hospital for mental disorders attributed to her loneliness. Just four years after her

marriage, Lee's progressively worsening condition deteriorated to the extent that she continually reached for imaginary objects. Authorities declared her insane and committed her to the Cleveland State Hospital.

Ong Foo, another of Cleveland's best-known Chinese residents, owned an East Ninth Street Restaurant. Possessing a secret chop suey recipe requiring twenty different ingredients, including many imported from China, he amassed a fortune selling chop suey dinners for thirty-five and fifty cents, depending on the portion size.

Although financially successful, Foo's restaurant endeavor provided its moments of frustration. In 1899, St. Clair Avenue resident Bessie Blake entered the eatery and, without any apparent provocation, proceeded to smash the furniture. Foo fetched a pail of water, threatening to douse Bessie if she continued her assault on the restaurant's fixtures. Equipped with a chair she had as yet failed to destroy, Bessie attacked the surprised storeowner. Charged with assault and battery, Bessie paid $7.45 in court costs but failed to reimburse Foo for the damaged furniture.

Foo had immigrated to the United States with Yee Hing; the two remained good friends throughout their lives. In 1900, after Foo's wife died in China, he journeyed back to his native land to bring Ong Ah, his seventeen-year-old son, to Cleveland. Foo anticipated that his roundtrip expense would be mitigated by remaining in China for one year. He estimated a good life in Cleveland cost about $500 annually, while a comparable lifestyle in China, including employment of a servant, would consume only $100. But Foo had no intention of just breaking even on his expedition. Transporting a bicycle on the trip, he functioned as a sales agent for a Cleveland manufacturer to introduce this trendy means of transportation to his native city and earned a hefty commission for his successful sales efforts. Planning for his return trip, Foo transported two large and empty Saratoga trunks to China, later to be filled with gifts for his friends in Cleveland. Anticipating possible problems with immigration officials, he also carried letters from local judges and officials attesting to his good character. But his meticulous preparations did not circumvent serious difficulties on his return voyage.

Sadly, Foo left his only son behind because United States immigration laws would not allow a dependent child to enter the country. At the time of his month-long return trip, a ship that Foo might have boarded sank outside San Francisco. After several weeks without communication from Foo, Clevelanders mourned his probable death. Although Foo had taken a different ship, incorrect immigration papers forced him to spend seven weeks in a San Francisco jail, even though he still possessed his reference letters.

Finally, authorities allowed Foo to send a communication to Cleveland, where influential city leaders helped obtain his freedom.

After the initial success of Yee Hing's marriage, the fifty-year-old Foo pursued a similar arrangement in Chicago with wealthy parents seeking a husband for their seventeen-year-old daughter. Suffering from rheumatism, Foo desired a wife to look after him in his declining years and to run his restaurant. He abruptly changed his plans following a business trip to Chicago in which he first cast his eyes upon the highly educated budding bride. In a reasonably accurate English translation, Foo referred to her as "downright ugly" and canceled the arrangement.

Although Foo opened a new restaurant on East Sixth Street, his financial fortunes and standing in the Cleveland Chinese community deteriorated. In addition to his aborted marriage plans, business in his restaurant never gained enough momentum to reach a profitable level. Foo also engaged in potentially violent altercations with his fellow countrymen. Disheartened and unsuccessful after his failure to transport his son to America, Foo burned an image of the god responsible for good luck on the roof of a Chinatown building. He then searched the city, to no avail, for a place where the martyred god could not reach him or his business. Foo died within two years of his sacrifice of the Chinese god.

Charley Jung, one of Cleveland's most educated Chinese residents, rose to power as an Ontario Street restaurant owner and leader in the local On Leong Tong association. Born in Canton, China, Jung immigrated to Cleveland in 1889 at about the age of twenty-three. In 1904, demonstrating his commitment to embracing new customs while still retaining portions of his Chinese culture, Jung and his bride, Miss Shung Fung, chose not to participate in a traditional Chinese wedding ceremony. Instead, the two exchanged their vows in what should have been a simple American civil union. But the bride and groom requested that the ceremony be translated into Chinese, a difficult task for any Clevelander authorized to perform an American wedding. Not familiar with the Chinese language, Squire William Brown struggled through complicated conversions from English to Chinese. Both the bride and groom acted completely confused when hearing the Chinese version of "to have and to hold, for better and for worse, in sickness and in health." Finally, the squire modified the question by asking Charley if he would "keep his bride right." After several hours of tedious translations, Squire Brown concluded that the couple had most likely participated in a legal American wedding.

In 1911, Jung observed fewer Chinese immigrants intending to return to their place of birth. He noted that in earlier times, an immigrant owning a

laundry or restaurant could realistically save between $1,000 and $5,000, a sum that would allow a return to China as a prosperous merchant. By the second decade of the twentieth century, rising costs in both China and the United States had escalated the comparable figure to between $15,000 and $20,000, resulting in far fewer opportunities for Chinese to return to their homeland.

Jung participated in the growth of Ontario Street as Cleveland's first Chinatown. Protecting the rights of the Chinese, arbitrating disagreements and attempting to keep peace with rival tongs, Jung became known as the unofficial emperor of Cleveland's Chinatown. He later continued as an esteemed member of Rockwell Avenue's Chinese neighborhood.

In 1935, Jung marred his reputation by receiving a suspended sentence after pleading guilty to selling heroin to federal narcotic agents near a Rockwell Avenue apartment. In court, respected Chinese and Caucasian citizens both attested to Jung's excellent character and years of service to the community. Influenced by these testimonials, the prosecutor used a legal procedure called nolle prosequi to prevent Jung's deportation. Two years later, the now seventy-three-year-old Jung incurred a second arrest for a similar crime in almost the exact same spot. Demonstrating much less leniency, a judge sentenced Jung to three years in federal prison. Although legal maneuvers once again prevented his deportation, the second arrest ended Jung's influence within the Chinatown community.

Ah Jim, another Chinese leader, operated a laundry at the corner of Superior Avenue and East Seventy-ninth Street. He is most remembered for his involvement in struggles among differing factions of local Chinese groups. A former member of Peter Len Ling's highbinder gang in China, Jim fled the country in fear of his life. After a group of his peers had failed in an attempted assassination of China's emperor, the ruler

Ah Jim, a successful business owner, involved himself in disputes arising among local Chinese groups. *Courtesy of the* Plain Dealer.

retaliated by ordering the instant beheading of any known highbinder. By 1886, Jim had established a successful laundry business on St. Clair Avenue and become a naturalized United States citizen and member of the Second Baptist Church. But family feuds in China triggered bitter quarrels among Chinese businessmen in Cleveland. The Wong and Lee families, two of the wealthiest and most powerful dynasties in China, jointly owned a cemetery. A perilous dispute arose when the Wong group attempted to relocate the cemetery and replace it with new housing. Through the feudal system, both groups controlled thousands of warriors loyal to them. Their disagreement incredibly expanded into a war in China that continued for fifteen years and killed thousands of people.

The clash in China transformed two former Cleveland friends into archenemies. Ah Jim (a Wong family member) and Peter Len Ling (aka Peter Lee of the Lee family), a graduate of Oberlin College and owner of a Woodland Avenue grocery store, developed an intense hatred for each other. In an action Chinese social organizations considered punishable by death, Ah Jim furnished police with the location of a West Third Street gambling house owned by Ling. In broad daylight, three of the gamblers attacked him on the sidewalk as he departed from the Cleveland Police station. Crafting an ingenious escape, Jim freed himself not only from the original trio of attackers but also from a growing and unruly mob. He then raced back into the safety provided by the police headquarters. Believing the Ling group planned to kill him, Jim requested police protection. Authorities needed little convincing; Lum Hing, one of the three original attackers, had already informed officers that he would kill Ah Jim at the first available opportunity.

Ah Jim survived the incident, only to become caught up in an even more convoluted altercation. He instigated a police raid on the Wah Chong Tie import shop, claiming the store served as a front for gambling activity. Although no evidence of gambling existed, trusted Chinese residents told authorities Ah Jim had periodically demanded fifteen dollars from Wah Chong Tie and other merchants, threatening to expose their businesses as gambling operations or opium dens. The following day, police arrested Ah Jim on blackmail and extortion charges. In addition to bungling his shakedown scheme, Jim demonstrated ineptness in selecting a sixteen-year-old German bride. Although she kept her husband well informed of local, national and international news by reading the newspaper to him every evening, she must have expected more from the marriage. Two years after the wedding, Jim's intoxicated wife nearly succeeded in committing suicide by drinking carbonic acid. She abandoned him shortly afterward, leaving no forwarding address.

3
Lairs of Iniquity

Opium Dens and Gambling Houses

Dimly lighted opium dens, sometimes requiring a secret signal or password for admission, contributed to the enigmatic character of the Chinese community. The dens often lay hidden in attic eaves, murky basements or converted clothes closets.

Unlike the burning of tobacco, opium is inhaled through a vaporization process, which creates the grayish-white smoke streams so often associated with the drug. A typical turn-of-the-twentieth-century den supplied its clients with a black mass resembling molasses (hop), a long bamboo pipe with an attached pipe bowl, a lamp designed to facilitate vaporization and inhalation by harnessing the correct amount of heat, a cooking needle (yen-hook), cleaners and lighters.

Smokers dipped the yen-hook into the hop, removing a small batch about the size of a pea. Held directly above the lamp, the hop expanded to four or five times its original size. The user rolled the hop over the palm of his or her hand, stretching it into long strings. Following this initial preparation, the smoker rolled the hop back into its pea shape, placed the hop over a small hole in the drum-shaped pipe bowl and forced the yen-hook needle through the ball of opium into the hole in the bowl. Holding the pipe bowl close to the flame, the smoker sucked the pipe to inhale the smoke from the hop.

Most smokers consumed the drug in a reclining position because of the pipe's burdensome length and the potency of the drug. The den supplied mats and bunks or cots, either purchased in retail stores or individually constructed from strips of bamboo matting laid across wooden trestles.

Frequented by laundrymen and restaurant workers, lower-end opium dens consisted of uninviting hard wooden bunks situated in dingy, poorly lighted surroundings. *Courtesy of the Plain Dealer.*

The quality of the smoking paraphernalia mirrored the economic standing of the clients. In Cleveland's Chinese community, equipment usually reflected the poor status of the neighborhood. Smokers used bamboo pipe stems rather than pipes constructed from ivory, jade or porcelain. Instead of pipe bowls decorated with dragons, animals and symbols, Clevelanders made due with very mundane bowls. Mass-produced lamps did not match the beauty of the exquisitely crafted Peking glass lamps used by the wealthy.

In 1891, Peter Len Ling remodeled an old home into a combined opium den, gambling house, convenience store and Chinese Free Mason temple. The opium and gambling portions ranked among the most notorious establishments in the city. Located on a no-longer-existing portion of Woodland Avenue near East Ninth Street, patrons entered the two-story frame building through a small, first-floor retail store supposedly selling chopsticks, floor mops, Chinese snacks, whiskey and other goods. Except for the whiskey, a heavy coating of dust covered the merchandise, suggesting

Ling's clientele sought a different trade. Naïve shoppers actually attempting to purchase products usually found the front door securely locked, except during the New Year holiday, when Ling conducted a brisk business selling delicacies, sugarcane, tea and table wear.

The small opium hideaway, with a maximum capacity of twelve people, sat in a room directly behind the retail store's back wall. The building's first floor also contained a kitchen and storeroom. Although no visible interior staircase existed, a slight movement of a small fixture, disguised as a towel rack, opened a secret door exposing a narrow, winding set of rickety steps leading to an upper level. For the less adventurous, the second floor could also be reached using an outside set of stairs placed at the rear of the building. On this floor, a twenty-foot-long by twelve-foot-wide room accommodated Cleveland's first permanent Chinese temple (joss house). Complemented by a drum and cymbals, Chinese worshiped at a five-foot-high and three-foot-wide wooden altar. A pair of candles, each painted red, green and blue, sat positioned at the altar's left side, along with approximately one hundred prayer sticks; each stick contained a different passage from Chinese holy writings.

In addition to the temple, the upper floor contained a Chinese Mason lodge room. The Chinese Freemasons of Ohio held a conference, attended by 150 Ohio Chinese Masons, to formally dedicate the new lodge. The second floor also served as a staging area for organizing and disposing of silk smuggled into and out of the city.

Initially confined to Chinese visitors, opium dens later fostered lurid tales implicating Cleveland's Caucasian citizens. In 1891, sixteen-year-old Lizzie Shannon, a Lakeside Avenue resident, complained that Sam Wah had enticed her into an opium den, where he demanded intimate relations. Lizzie's credibility plummeted when she confessed to past immoral conduct with very young boys and substantially older Chinese men. The court dismissed her grievance. But exposure to cultural vices traveled in both directions. One of Cleveland's very few disrespectable Chinese inhabitants, a hard-drinking, unemployed derelict known as the "tramp Chinaman," acquired his craving for liquor from his equally loathsome white wife.

In 1894, three Cleveland ministers, accompanied by a police officer, embarked on a midnight field trip through the city's slum areas, including Ontario Street. The four observed many supposedly obvious opium dens, often intermixed among saloons and houses of prostitution. The following Sunday, Reverend A.B. Chalmers told the Dunham Avenue Disciple Church congregation:

When the clock strikes twelve at noon, we can hear the sounds of healthy activity and material progress. But when the same clock strikes twelve at midnight, then the works of darkness begin and, all night long, the devil holds high carnival, and if we could only hear a cannon boom every time a soul is plunged into seething sin, all night long we would hear the boom, boom, to wake us from our peaceful slumber as soul after soul is plunged and drowned in the depths of hell.

Police tended to ignore drug havens as long as their activity remained confined within the Chinese community. But the three ministers' subsequent fiery sermons demanded police action and resulted in a series of raids. Reverend Chalmers personally escorted detectives to an Ontario Street opium den, which he had observed on his midnight walk. During the day, Charley Foolock operated a grocery store on the premises. Police observed jars, bottles and boxes of groceries, unfamiliar-looking vegetables, crockery ware and painted feathers, but no signs of opium use. Foolock invited the detectives and Reverend Chalmers to inspect his store, either in day or night, for evidence of opium. He informed the police that Chinese often smoked tobacco using long pipes that could have been easily mistaken for opium use, especially by the minister, who "lacked the experience to make him a well-educated, worldly man." Another member of the Chinese community speculated that Reverend Chalmers couldn't distinguish the odor of opium from that of dried fish.

Despite this setback, other raids did uncover a large number of functioning opium dens. Laundryman Sam Kee (aka Tom Sing), previously arrested for operating a den on Hamilton Street, suffered another detainment for managing a new establishment on East Third Street in the basement of a former church. Kee jumped bail and departed for Chicago, where he served a jail sentence for assault with intent to rob. Another local raid led to the arrest of the infamous Peter Len Ling, the most recent occupant of Kee's former Hamilton Street den.

Fearing a nighttime raid, Chin Wood operated his St. Clair Avenue opium den only during the morning and afternoon; enterprising policemen countered his strategy with an afternoon visit. Other raids resulting in arrests focused on Charles Hooks, doing business on Lakeside Avenue, and Quoong Hang, an Ontario Street operator. In addition, detectives arrested Harry Lee, Au Sing and Charles Sing, all managing dens entered through back doors in downtown alleys.

Huie Gimm and Minnie Moore, his blond Caucasian wife, operated a laundry in the basement of a building situated on the southwest corner of

Ontario Street and St. Clair Avenue. Huie, combining missed promised dates with inferior work, did his best to discourage his already tiny customer base. The laundry functioned merely as a front for a well-attended and much-raided opium den sitting in the shadow of the Old Stone Church.

During this period, Mame Younge, a woman employed by a local private detective agency, worked undercover to secure evidence for private clients. Her assignments involved entering opium dens and gathering information by convincingly pretending to take part in the vice. Her investigations abruptly ended when a patron recognized her as a detective. The den owner saved Younge from almost certain strangulation by a mob of angry patrons. After chloroforming her, he sent Younge on a horse-pulled wagon to an undisclosed destination; fortunately, police rescued the detective during her trip. Undaunted by the experience, Younge later worked as an undercover gambler and also exposed an executive blackmail scheme.

At a national level, the Chinese, once chastised for taking jobs from Americans, now faced blame for importing the opium-smoking habit. The Committee on the Acquirement of the Drug Habit, a 1903 blue-ribbon citizens' panel, concluded, "If the Chinaman cannot get along without his dope, we can get along without him." A few years later, the *New York Times* quoted Dr. Hamilton Wright, the country's first opium commissioner, as claiming, "One of the most unfortunate phases of smoking opium in this country is the large number of women who have become involved and living as common-law wives or cohabitating with Chinese in the Chinatowns of our various cities."

Events in Cleveland emulated the national trend. Chinese and Caucasian cultures intermixed as a growing number of Cleveland's white residents, along with visiting sailors, frequented opium dens, some now owned by Caucasians. Outraged citizens demanded further crackdowns when a search of Joe May's East Third Street den uncovered two fifteen-year-old female opium smokers and a raid of Leou Yen's Chester Avenue den exposed fourteen-year-old Dora Corceran, clad only in a nightgown. In response, detectives raided downtown opium dens on Lakeside Avenue, Ontario Street, Woodland Avenue, Chester Avenue, St. Clair Avenue, East Eleventh Street, Bethel Court and Bolivar Street. The largest operation, a more upscale venture located in the basement of the Chinese Reform Association on Ontario Street, provided opium smokers comfortable coaches rather than the more commonplace cots.

Despite the small number of Chinese residing in Cleveland, the city in 1907 ranked fourth in the country in the number of opium dens, surpassed

In the 1890s, handsome opium dens, often located in private residences, appealed to upper-class Chinese and Caucasian clientele, including women. *Courtesy of the* Plain Dealer.

only by San Francisco, Chicago and New York. Besides high-profile newspaper accounts, Cleveland's wealthier population became exposed to the evils and excitement of opium through sensational melodramas playing

in local theaters, among them *King of the Opium Ring*, *Chinatown Charley: The Opium Fiend* and *The Queen of Chinatown*.

In 1909, a reform government in China prohibited the sale and exportation of opium. As availability declined, the drug's price soared from twelve dollars to thirty dollars per pound, paving the way for two new businesses. The second floor of Sun Wah Chong's Ontario Street importing company turned into a combined opium den and recycling plant. The ashes of burned opium, mixed with the pure drug, created a less-expensive alternative for opium smokers. About the same time, Mary Baldwin advertised a home-cure remedy to permanently end opium, morphine and cocaine addiction.

Five years later, proprietors of opium dens faced another formidable challenge. The 1914 Harrison Narcotic Tax Act radically changed drug enforcement tactics. The law, established to regulate and tax the production, importation and distribution of opium, also empowered federal agents with the authority to raid suspected opium dens. The agents not only arrested offenders but also assessed taxes on the dens' owners.

Disguised as express wagon employees, in 1917, Internal Revenue agents delivered a suspicious package to Quong Yuen's Ontario Street merchandise store. The driver removed a white handkerchief from his pocket and wiped his forehead, a signal to other agents that a store employee had accepted the package. The ensuing raid of the business and an adjacent rooming house uncovered opium users remaining in heavy stupors even when dragged from their cots. Agents discovered false partitions concealing closets storing large quantities of opium and associated paraphernalia. Up to that point, the raid constituted the biggest opium discovery in Cleveland's history.

In 1930, as the Ontario Street buildings faced demolition, two automobiles filled with federal narcotic agents raided Yee Hing's tea importing company after kicking in the front and rear doors. The agents confiscated two thousand grams of opium, along with pipes, chests and a ledger containing a history of opium sales. These records indicated that Cleveland served as a major distribution point for opium between San Francisco and New York. In another raid, narcotic agents seized opium from an Ontario Street building housing a Chinese children's school. Fifteen-year Cleveland resident Fong Bing, a salesman for the Chinese Merchant's Association, earned the dubious honor of becoming the last Chinese person arrested on a narcotic charge in the old Ontario Street Chinatown. Fined $100, Bing also served a fifteen-day jail sentence.

Federal agents quickly repositioned their efforts to the newly established Rockwell Avenue Chinese neighborhood. In an otherwise-vacant building, a

second-floor lookout opened the heavy street-level doors only after carefully scrutinizing each visitor. Agents patiently waited three hours before rushing into the building as the owner entered. The 1931 raid constituted the first drug-related altercation in the new Chinese enclave. The building's street level would later house a barbershop, cigar store and fishing tackle shop.

A 1938 raid of the private residence on Rockwell Avenue netted opium, pipes, smoking accessories, a revolver, five gallons of rice whiskey and opium ashes. Ornamental ivory and inlaid German silver decorated one of the polished bamboo pipes. The next year, federal agents combined with Cleveland vice squad detectives to raid an apartment above Jessie Wong's popular restaurant, along with a nearby general merchandise store, to obtain $100 worth of narcotics, illegally produced red wine, two stills and $30 in marked money previously used to purchase drugs.

Opium dens became passé as the drug's stronger derivatives, notably morphine and heroin, increased in popularity and could be easily self-administered. Rather than operating dens, modern dealers merely supplied the drugs. In the early 1940s, a two-story Payne Avenue house, almost next door to the Central Police Station, housed a Chinese laundry and opium dealer. The proprietor purchased the drug in New York, reselling it to Clevelanders at a handsome profit.

Gambling houses added another mysterious dimension to the community. Gaming so pervaded Chinese culture that the community paid homage to both a national gambling god (Li-Nezha) and a local god (Tu Thieng King). Prior to going on a gambling trip, many Chinese made offerings to these gods.

About fifteen to twenty people typically frequented a gambling quarters at one time. Sometimes these players engaged in high stakes; one bettor lost $5,000.00 in only a few nights of wagering in gambling establishments commonly operating in basements of laundries, upper floors of private residences and rear rooms of grocery stores. In 1888, King Gee managed his combined gambling house and opium den in a West Third Street building housing the Chinese Free Mason Society. The Masons allegedly collected $0.70 from every $10.00 of bets. In addition to operating gambling games, owners or dealers assumed responsibility for arbitrating disputes and enforcing proper etiquette within the establishments. Not all dealers construed rules of etiquette in the same manner. In 1894, Sam Sing, playing poker in Peter Ling's gambling house, complained about a misdeal. In response, the dealer hit him over the head with a club.

The coexistence of Chinese gambling houses and opium dens generated intriguing illustrations of cultural assimilation. In 1893, the *Plain Dealer*

estimated that about four to five hundred people frequented the city's opium dens even though Cleveland's Chinese population numbered fewer than one hundred. The newspaper attributed the disparity to "non-Oriental Clevelanders" partaking in the vice. At the same time, Chinese enthusiastically learned the fundamentals of poker from American gamblers.

In the nineteenth century, fan-tan and pai gow thrived on Saturday and Sunday evenings in Chinese gambling houses. In 1890, Leun Loui described fan-tan to a *Plain Dealer* reporter as "just like dice, only a little different." Using a mat-covered table about four feet in height, fan-tan gamblers used coins, buttons, beads, rice, dried beans or similar small objects. The dealer grabbed two handfuls of these items from a large pile, quickly covering them with a cup or bowl.

The game's objective centered on correctly guessing the remaining number of objects after the dealer divided his chosen heap into four equal smaller piles; the remainder must be one of four possibilities, either zero, one, two or three. A railed area at the table's side contained the cashier's tall chair and wooden stools for the gamblers. The players placed bets beside numbers corresponding to the four possible remainders. The dealer used a small bamboo stick to remove the objects, four at a time, from the heap. The final batch determined the winners. Variations in the game allowed for different types of wagers. In these respects, fan-tan bore a resemblance to roulette games. The cashier paid the winners after deducting a 7 percent commission to cover the profit and overhead, possibly including payment of lookout men, protection money and police payoffs.

In another version of fan-tan, the dealer tossed a similar set of objects onto a table. Quickly covering the bulk of the scattered objects with a cup, bettors placed wagers on whether an even or odd number of objects remained under the cup. Fan-tan is also the name of an unrelated card game.

A pai gow player received four dominoes, which he converted into two sets, each containing two dominoes. To win, a player must have created both a higher number than the dealer's high hand and a lower number than the dealer's low hand. An Americanized version developed into the still-popular pai gow poker game.

Chinese lotteries of the period bore little resemblance to today's lottery games. Typically, a board contained paper representations of eighty Chinese characters, each about five inches in width and length, arranged in columns of four characters each. Each gambler chose a set of any ten characters. Following these choices, the manager removed from the board each paper character and carefully rolled up each piece, placing them in a tin can. After

thoroughly shaking the can, the manager removed the characters, one at a time, and divided them equally into four smaller cans so each container held twenty characters. The manager selected one of these smaller cans by casting lots. As anxious bettors waited, the manager revealed each of the twenty characters in the selected can. If a player had chosen four or fewer of these twenty characters in his ten-character bet, he lost all his money. For each dollar wagered, the gambler received $2 if he picked exactly five characters, $20 for exactly six, $200 for seven, $1,000 for eight, $2,000 for nine and $4,000 for ten.

Gambling progressed beyond the use of buttons, cards, dominoes and paper characters. In 1898, a visitor from Mexico introduced the city to the ancient Chinese sport of cricket fighting. Importing twenty-five pugnacious crickets from his homeland, he staged numerous battles where the male insects bit, clawed and leaped during skirmishes persisting for up to five minutes. In China, fight promoters aroused the aggressive spirits of male crickets by introducing them to a frisky female cricket just prior to the battle. The Mexican promoter inspired a more violent fight by touching the nose of each warrior with a straw doused with a concoction produced from cactus juice. The brew greatly irritated the crickets' tempers, resulting in brawls where an opponent would rip off the legs of an adversary and often blind him. Despite offering novel entertainment and the opportunity to stage wagers, cricket fighting never captured the imaginations of either the Chinese or the general Cleveland population. The Chinese may have failed to appreciate the brutal Mexican version when contrasted with a more subtle Chinese sport involving carefully bred pedigree crickets subjected to a high degree of conditioning and training.

Superstitious Chinese gamblers adhered to many rules of conduct. They refrained from gambling just after having sex or following an encounter with a priest or nun. Chinese never entered a gambling house by the front door and, on their way to a gambling house, would turn back upon encountering a wagon or other obstruction in the road. Gamblers refrained from reading books before wagering because the translation of the word "book" sounded similar to the phrase "to lose." Country singer Kenny Rogers Americanized a cardinal Chinese rule—never counting money while in the process of gambling—in his pop hit song "The Gambler." On the positive side, wearing red clothing, especially underwear, generated good luck. Proprietors of gambling houses observed their own set of superstitions. Owners promoted bad luck for the players by painting the walls of gambling rooms white, a color associated with

losing money. To encourage their own good fortune, proprietors placed pieces of orange peel in the rooms, a sign of prosperity.

In the early 1920s, Chinese businessmen at times tacked large signs onto their Ontario Street stores and restaurants, a practice that piqued the curiosity of Edwin D. Barry, Cleveland's safety director. The inquisitive administrator hired an interpreter who translated the text into the American message: "Gambling now going on here. Never mind the police."

Participation in gambling continued for decades. In 1993, a two-year FBI probe of Chinese sports gambling in Cleveland resulted in a federal raid of fifteen restaurants and residences, some located in the current AsiaTown area. Federal prosecutors eventually charged thirteen men with operating a gambling organization that collected more than $1 million per year, primarily on football wagering. All defendants pleaded guilty in plea bargaining agreements. Today, Asians congregate around baccarat tables in the downtown Horseshoe Casino. Two casino employees, natives of Hong Kong, act as liaisons for Asians visiting Cleveland's largest gambling house.

4
Tong Wars

Mayhem, Meat Cleavers and Murders

In 1911, the On Leong Tong, primarily a merchant association, and the newly established Cleveland chapter of the Hip Sing Tong, chiefly composed of laundrymen and other workers, extended a bitter feud that had already erupted into violence in the Chinatowns of San Francisco and New York.

Although Cleveland's Chinese population numbered fewer than 250, the Hip Sing Tong employed three local gunmen (enforcers) reminiscent of the highbinders from China. The tong extorted protection money (typically $2.50 per week) from Chinese business owners, threatened proprietors who refused to pay and killed especially uncooperative merchants. Based on their previous experience in executing shakedowns, the thugs earned a base salary averaging $8.00 per week and collected a $0.50 kickback for every payment of protection money. The gunmen could also earn an extra $300.00 bonus for the authorized murder of a rival tong member or a Hip Sing colleague who turned against the organization.

Woo Dip, owner of a Cedar Avenue laundry and member of the On Leong Tong, refused to pay protection money after the Hip Sing increased his assessment to $3.50 per week. Encouraging other merchants to follow his lead, Dip anticipated an unpleasant visit from a local enforcer. The inevitable drama took place on the evening of November 20, 1911. Dip had just entered an On Leong gathering place located in an underground room in the rear of an Ontario Street Chinese grocery store. A Hip Sing member easily penetrated the rival sanctuary, fired three bullets into Dip's back and

abdomen and disappeared into the darkness. On Leong Tong members identified Leon (aka Lang) Young as the assailant.

Within an hour of the shooting, police initiated raids of every Chinese restaurant and laundry in the city but failed to apprehend Young. Less than forty-eight hours after the shooting, leaders and hit men from New York, Chicago, Washington and Philadelphia tongs hurried to Cleveland to prepare for war. The tongs averted large-scale violence, partly because Woo Dip amazingly survived the murder attempt.

The On Leong Tong offered a $500 reward for information regarding the shooting, even though the Hip Sing Tong had threatened to kill every local On Leong member if the reward remained in effect. The shooting and threats prompted retaliation by the On Leong Tong, although not the expected violent response. Asian culture discouraged any interference by Western Americans; the Chinese preferred to settle their own disputes. Yet On Leong Tong members described to police various Hip Sing extortion plots and disclosed the whereabouts of several national Hip Sing members wanted for various crimes, including a New York Chinatown murder allegedly committed by Leon Ling, a cousin of Leon Young. Based on information provided by the tong, Cleveland police raided local Hip Sing members' homes and businesses, in the process confiscating a large amount of opium.

Although unable to locate Leon Young, police arrested two accomplices to the shooting, Jew Pang, president of the local Hip Sing chapter, and Dar Gim (aka Gam), the chapter's founder. As the trial neared, potential witnesses received intimidating letters threatening to harm their families; some Chinese fled the city in fear.

During the trial, the first of two dramatic events unfolded when Hip Sing enforcer Yee Chang identified Jew Pang as the person who ordered the Woo Dip murder. According to Chang, Pang handed a gun to Young, instructed him to shoot Dip and added, "Make sure you kill him." Chang's disloyalty understandably stunned the Chinese community. At a Hip Sing Tong's member initiation, each new associate received a handsome certificate of membership set in brilliant red silk. The organization also invited each new member to inspect an equally stunning razor-edged cleaver, depicted as the insignia of death to any member who betrayed the association.

As the trial progressed, police arrested Woo Qut, a Hip Sing assistant collector of protection money who offered a stunning corroboration of Chang's testimony. Irritated because the Hip Sing had not provided him bail money, Qut's further motivations to turn against the tong involved a blood

During initiation rituals, new tong members learned that violating an organization's code of ethics could result in a slashed throat administered by a knife, sword or meat cleaver. *Courtesy of Special Collections, Michael Schwartz Library, Cleveland State University.*

relationship and business partnership with Dip. Despite being members of rival tongs, cousins Dip and Qut jointly owned a grocery store near where Dip's shooting took place.

A jury deliberated less than five hours before agreeing on guilty verdicts. The aggravated Hip Sing Tong predicted that two On Leong members would be killed to avenge the convictions. Meanwhile, Hip Sing constituents kept their window shades drawn as rumors persisted that On Leong hatchet men had arrived in Cleveland to kill the entire Hip Sing membership.

During the trial, Woo Dip had identified Chin Sang and Louie Won as two more Hip Sing members aiding Leon Young in his attack. Police needed only a few seconds to arrest the kicking, clawing and screaming Won, who happened to be present at the trial when Dip made his accusation. Shortly afterward, detectives apprehended Sang on Superior Avenue. Obtaining temporary freedom on bail, Sang and Won encountered a second arrest when the sheriff seized the pair as they climbed out of a rear window in the Hip Len Wah Company, the first stage of their planned attempt to skip town. Woo Dip relocated to Columbus, where he established a new laundry business. Pang, Gim, Sang and Won all received prison terms, shortened by a judge who doubted the accuracy and understanding of the court interpreters. But these events did not bring an ending to the violence associated with the attempted murder of Woo Dip.

In 1913, Columbus police discovered the body of Sam Wah Tang, a Hip Sing member stabbed to death with an ice pick while he slept in a Columbus rooming house. Woo Gew, asleep in the same bed, suffered an axe blow that split his head open. Before his Columbus residency, Tang's Cleveland activities consisted of owning a restaurant located on West Twenty-fifth Street at Franklin Avenue, working as an interpreter at the Woo Dip trial and assisting in obtaining pardons for Jew Pang, Dar Gim, Chin Sang and Louie Won.

Henry Moy Fot, a prime suspect in the Sam Wah Tang murder, promptly disappeared. A wealthy Cleveland merchant, Fot also headed the rival On Leong Tong. Based on a tip from the Hip Sing Tong, a Cleveland detective authorized a pseudo-vigilante committee, composed of Hip Sing members, to travel to Pittsburgh to arrest Fot. Although no one apprehended Fot, the exiled Clevelander mailed a postcard to the detective who sanctioned the Pittsburgh excursion in which he wished good health to the detective's family.

The following year, Cleveland police received a telegram from San Francisco announcing that the much-sought-after Leon Young had been arrested. Cleveland On Leong Tong members, who had learned about the arrest before the local police, promised to testify against Young. The evening before the beginning of the trial, tong members prepared for the ordeal by listening to ragtime music played on an electric piano while dining on a banquet consisting of bird's nest soup, pickled eggs, melon seeds, shark fin soup, rice and ginger wine.

Young claimed a case of mistaken identity, testifying that he resided in San Francisco, had never visited Cleveland and did not know any of the people involved in the trial. A jury needed about one hour to convict Young.

Sentenced to twenty years in jail, Young chose imprisonment rather than an attempt to obtain a parole because he considered living in jail much safer than walking Cleveland's streets. To no avail, his attorney later claimed that Young had acted in self-defense since he knew he would be killed if he failed to carry out his shooting assignment.

Following Young's trial, an uneasy calmness prevailed, periodically interrupted by sporadic incidents. A gun battle erupted on the corner of Ontario and Hamilton Streets. On another occasion, a bullet, fired into a window of the downtown Suey Wo Chung Restaurant on Rockwell Avenue, struck a chop suey bowl, split the bowl into three pieces and splattered its contents on surprised dinner guests. But this relative calmness ended by the mid-1920s, when renewed tong wars reached new levels of viciousness.

Yee Hee Kee, a senior member of the On Leong Tong, resisted a control takeover by the organization's younger constituents. The upstarts countered by placing a $7,000 price on the influential member's head. On May 29, 1924, in an incident akin to guerrilla warfare, two gunmen shot Kee five times in front of his import store, firing bullets into his back, hip, gut and left hand. While recovering at Lakeside Hospital, Kee received a basket of flowers with a note indicating that the gift had been originally intended for his funeral. He disappeared from the hospital, never to be seen again in Cleveland. Later, in New York, one of Kee's two alleged gunmen killed the suspected second assailant and then committed suicide, bringing closure to the Kee murder attempt.

Just a few weeks after the Kee shooting, with potential violence pervading every street corner, the On Leong Tong staged its national convention in Cleveland. As a precautionary measure, police searched rooms in every Chinatown building, breaking down locked doors when necessary, in a hunt for "suspicious-looking" Chinese. Police offered the thirty-one persons arrested in the raids two options: stay in jail or be escorted to Cleveland's train station, where they would remain in custody until detectives observed them leaving town. The majority of those arrested chose the exit alternative.

During the convention, members officially expelled Yee Hee Kee, Gong Wo and Wong Sing (a former Cleveland On Leong president), charging the trio with misappropriation of tong funds. Gong Wo, once the association's national president, observed his name posted on Ontario Street as one of twelve former tong members to be killed on sight. Wong Sing claimed he had been a victim of an extortion plot carried out by Chin Jack Lem and seven other tong members. Sing told police he had

Above: In 1911, Wong Sing (left) watched over his Ontario Street store. He became a victim of an extortion plot during the turbulent 1920s. *Courtesy of Cleveland Public Library, Photograph Collection.*

Right: A bitter dispute between Chin Jack Lem and Wong Sing resulted in On Leong Tong members breaking their sacred vows of secrecy regarding the organization's conduct. *Courtesy of the* Plain Dealer.

CHIN JACK LEM
DEFENDANT

WONG SING
—CLEVELAND PRESIDENT OF ON LEONG TONG ON WITNESS STAND

been kidnapped at gunpoint and forced to sign away the tong's $70,000 property on East Twenty-first Street.

One On Leong member characterized Lem, another former On Leong Tong national president and purported current Hip Sing member, as the most dangerous Chinese person in America. Lem rarely appeared in public without wearing a bulletproof vest beneath his shirt. Arrested in Chicago for his part in the scheme involving Sing, Lem jumped bail.

The alleged extortion incident resulted in the arrests and trials of the other seven implicated in the plot: Yim Fong, Gong Wo, Moy Dong You, Harry Gong Shue, Ng Yee Lai, Yee Lock Jung and Yee Chew. Fong broke his sacred Chinese oath to testify that he and the other members on trial had pressed pistols against the neck of Wong Sing, threatening to kill him unless he signed a document releasing the property. The group's plan apparently consisted of obtaining a $30,000 bank loan by offering the property as security, dividing the money among the eight members and four additional gunmen and fleeing the city. A jury found all seven guilty; each person received a sentence of between three and twenty-five years in prison. In his only request, Fong asked that he not share the same cell with any of the other six. After New York police captured Lem, a jury needed about one hour of deliberation to convict him. He received a sentence of fifteen years in jail.

In August 1925, the Hip Sing Tong announced a major convention would be held in Cleveland the following month. The On Leong Tong complained its rival had no intention of staging a convention; rather, the Hip Sing planned to import gunmen to fight the On Leong Tong. Edwin D. Barry, Cleveland's safety director, ordered police to guard all railroad stations and send any "strange Chinese" to jail. As news spread regarding the On Leong Tong's efforts to block the convention, a national tong war erupted. Violence, resulting in murders, extended to the Chinatowns of New York, Chicago, Boston, St. Louis and Pittsburgh. Remarkably, Cleveland's Chinatown remained quiet, if only for a short time.

When police arrested two On Leong Tong members on concealed weapons charges, Barry ordered all of the organization's members out of the city. According to the *Cleveland Times*, Barry shouted at Tom Chan Poy, the secretary of the tong:

> *When a tong war threatened Cleveland's Chinatown about two weeks ago,*
> *I called you fellows, the heads of both tongs, into my office and told you that*
> *I wouldn't stand for any more chink murders here. Now I am giving you,*
> *the Secretary of the On Leong Tong, just thirty days to fix up your business*

and get out of town. And we are going to see that you stay out, too. Tong wars have got to stop in Cleveland. We'll stop 'em if we have to chase every chink out of the city and keep 'em out.

But Poy faced an obstacle to abiding by Barry's orders: federal narcotic agents, investigating a drug raid, had ordered the tong leader not to leave the city. In addition to remaining in Cleveland, Poy later obtained United States citizenship and earned a reputation as a respected activist in Chinese affairs.

On September 22, 1925, prior to Barry's deadline for leaving the city, tong-inspired violence reached a new level of brutality just hours following a declaration of truce between the On Leong and Hip Sing factions. As Yee Chock, a twenty-six-year-old waiter, rested in his third-floor attic room on Ontario Street, assailants used a meat cleaver to sever his spinal cord in three places. Fellow On Leong Tong member Mark Ham, a sixty-five-year-old laundryman, claimed he discovered Chock's decapitated body and observed three men

In 1925, following the edicts of Cleveland's safety director, police detained every observable Chinese person and transported them to jail. *Courtesy of Cleveland Public Library, Photograph Collection.*

Discovered playing in the halls of an Ontario Street building, police hauled this nine-year-old child to jail during their mass arrests in 1925. *Courtesy of Cleveland Public Library, Photograph Collection.*

hurriedly leaving the building. Assuring police he could identify the killers, detectives escorted Ham to the Hip Sing headquarters, now located on East Fifty-fifth Street. Ham positively identified one Hip Sing member as a slayer and implicated two others.

Meanwhile, police searching Chock's room discovered two meat cleavers, hammers and six knives, two with eighteen-inch blades, all bloodstained and lying near the body. Detectives also found fingerprints on a bloody stick most likely used to bar the door during the murder. Barry reasoned that since most Chinese murders resulted from internal disputes, matching the fingerprints on the stick to those of a Chinese community member would solve the murder. But Barry faced an obstacle in implementing his plan since fingerprints of the entire community did not exist. To resolve this apparent impediment to justice, Barry ordered police chief Jacob Graul to arrest every Chinese person in Cleveland for photographing and fingerprinting. To enhance the speed of the process, the chief suspended policemen's days off and eight-hour workdays.

Graul carried out his assignment with great vigor and attention to detail. In addition to adults, detectives arrested every Chinese child they encountered, along with junior and senior high school students and scholars studying at Western Reserve University and Case School of Applied Sciences. Within twenty-four hours, 612 of the approximately 700 Chinese residing in the city had been arrested. Barry warned, "Every Chinaman we can get our hands on is going to stay in jail until the slayers are turned up." Wealthy merchants stood next to the most lowly laundry laborer in jails so filled beyond capacity that captives sitting or lying down risked being trampled upon; many of the detainees spent the night attempting to sleep while standing up. One laundryman, expecting to remain for only a few hours, left the fire going in his shop; when he returned the next day, he found the shop had burned down.

William P. Lee, the national secretary of the On Leong Tong visiting the city from Pittsburgh, protested his own arrest. He claimed he came to Cleveland to assist police in solving the murder. Barry retorted, "The quicker you solve the murder, the quicker you get out of jail."

In addition to the civilian arrests, Barry ordered, "Every Chinese restaurant and laundry in the city is going to stay closed up until we get the information we want." Police shut down all the Chinese businesses in the city. Since the detainment of the Chinese people and the closing of their businesses constituted front-page news, robbers easily broke into laundries, stealing money and clothing.

City manager William R. Hopkins threatened to raze every Chinese home and business on Ontario Street. To implement his plan, health authorities raided the buildings, breaking down the doors to most establishments in their efforts to investigate fire and sanitary code violations. Without being hindered by doors, Cleveland residents conducted their own explorations of the temporarily abandoned and unlocked Ontario Street buildings, taking samples of spiced nuts and other delicacies. Upon discovering gleaming On Leong temple relics, the looters pilfered most of the artifacts.

Judges quickly denounced the wholesale arrests as illegal, quoting both law passages and verses from the Bible. The incident caused an international uproar. The State of Ohio, United States government and Chinese diplomats all registered strong protests. Locally, complaints ranged from the blatant violations of civil rights to Clevelanders' inability to retrieve their clothing from closed and looted laundries. A vast majority of the arrested Chinese gained their freedom in twenty-four hours. Unfortunately, the poor quality of the bloodstained fingerprints rendered such evidence useless in the investigation.

Dismayed by the mayhem already generated, Mark Ham created a shocking twist in the murder investigation by admitting his part in the Chock killing. According to Ham, the On Leong Tong had slaughtered one of its own members to discredit and frame the Hip Sing Tong. In addition, the tong reasoned that the murder would almost guarantee the outbreak of a new tong war since a peace treaty between the two groups had just been agreed on. Past treaties had always proved problematic for the tongs' hit men working on commission; voiding the treaty and creating a new war would put more money in their pockets.

Ham's assignment consisted of three tasks: acting as a lookout prior to the killing, pretending to discover the body and alerting the police. As a reward, the tong promised Ham a high-paying job at a gambling house. He identified the two murderers, both of whom had been arrested the day before but freed following criticism of Cleveland's illegal tactics and never seen again.

During Ham's trial, the On Leong organization maintained that a hostile Hip Sing interpreter had secured an invalid confession by tricking Ham, who spoke no English. But Ham's entire creditability became an issue when the court learned he currently remained free on bail while awaiting trial in Chicago on a murder charge. One evening, as the trial progressed, Ham tied part of a linen blanket into a rope, threw the linen around an overhead pipe and hanged himself. The suicide brought an abrupt conclusion to the trial. Less than one year following the murder, the building owner transformed the room where Yee Chock met his brutal death into an opium den.

Ham's testimony inspired the Ohio State Board of Clemency to presume that the defendants in the Wong Sing extortion trial might have been similarly framed by the On Leong Tong. In 1928, all seven of the convicted men received paroles after serving minimum three-year jail terms. Three years later, Ohio governor George White commuted Chin Jack Lem's sentence on the condition that he would never return to Cleveland. Lem moved to Louisville, Kentucky, where he opened two restaurants while living with one of his nine sons. Six years after Lem received his freedom, a gunman shot and killed him on a Chicago street where Lem had planned to launch a restaurant. Although police never discovered the killer or the motive for the murder, Lem's relatives claimed he had been accused of keeping money collected to aid mainland China citizens during the war with Japan.

Two months after the 1925 mass arrests, one thousand Hip Sing Tong members held their national convention at the East Fifty-fifth Street, Cleveland headquarters. Not expressing any opposition to the gathering,

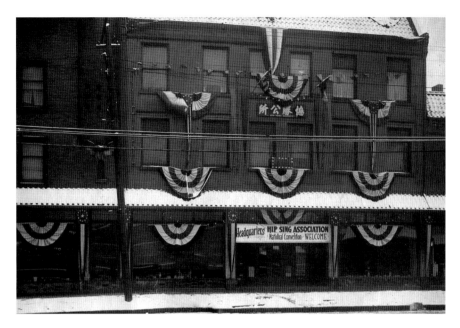

The Hip Sing conducted its 1925 national convention at the organization's headquarters, located at East Fifty-fifth Street. *Courtesy of Special Collections, Michael Schwartz Library, Cleveland State University.*

Safety Director Barry claimed, "All they do at these Chinese conventions is parcel out gambling concessions." The national Hip Sing organization forbade members from any involvement in the Chin Jack Lem affair. As a sign of peace, several On Leong members attended the closing banquet. Cleveland Hip Sing leader Wong Bowe, probably content that police attention had turned to their rivals, declared that some good had come from Barry's mass arrests.

Later in 1925, police found On Leong Tong member Lul Low hacked to death in his Lexington Avenue laundry, but no other outbreaks of violence occurred. On March 23, 1927, a formal truce between the two tongs expired. Five days later, white flags with red borders, commemorating the signing of a new permanent national peace treaty, soared above the headquarters of the Cleveland tongs. Yet in the short period between the expired original treaty and its replacement, a gunman fired three bullets into the body of Lee Yick Gar, the owner of a Chinese laundry on Euclid Avenue near East Sixty-ninth Street. Gar may have been shot because of his decision to join the On Leong Tong, but many believed his death avenged the killing of a Chicago Hip Sing Tong member the night before. Whatever the reason, Cleveland

police detective Cornelius W. Cody threatened to "put tong leaders in jail and throw away the key" if any further outbreaks occurred in Cleveland.

Gar survived the shooting and indentified Woo Fang as the gunman and local Hip Sing president George Yee as an accomplice. Fang disappeared, never to be heard from again. Two juries failed to reach a decision regarding Yee's guilt or innocence. During a third attempt, a judge allowed the administration of a Chinese oath, since the Chinese did not honor American oaths. This decision created some logistical issues since each oath required the sacrifice of a live rooster. Even more daunting, the rooster's demise needed to take place above the grave of a deceased Chinese person, since Chinese would not dishonor their ancestors by telling a lie over their remains.

City officials drove George Yee, Lee Yick Gar, a few other witnesses and seven roosters to West Park Cemetery, located on Ridge Road near Dennison Avenue, where sixty-five Chinese had been laid to rest. West Park, along with Woodland Cemetery on the east side, constituted two of a very small number of cemeteries allowing Chinese burials. There, George Yee proclaimed, "Before my ancestors and all the Gods of China, I hope that God may strike me dead as this chicken, the head of which I chop off, if I was present at the laundry at 6815 Euclid Avenue on March 24 between 6:45 a.m. and 7:30 a.m. or any other time on that day." Yee then cut the head from the rooster. Gar refused to take the oath, necessitating a second trip when the judge demanded that he do so. The third jury found Yee not guilty.

The 1927 violence ended the tong wars in Cleveland. In 1930, renewed tong hostilities resulted in murders in New York, Chicago, Boston and Newark, but the Cleveland Chinese neighborhood remained calm. Although both organizations still exist, the tongs' influence waned as Chinese immigrants grew more successful and integrated into American culture. Today, Cleveland's tongs function mainly as business development and cultural-preservation organizations, upholding Chinese traditions and enhancing the well-being of Chinese business enterprises.

5
Cleveland's New Chinatown

The Rockwell Avenue Era

As wrecking balls waited to demolish the Chinese community's Ontario Street business and residential center, On Leong Tong members broke ground for their new Rockwell Avenue headquarters near East Twenty-first Street. Wearing pink carnations in their lapel holes, prominent leaders took turns removing dirt with a shovel whose attached bright red ribbon encouraged good luck. Six months later, the impressive new building stood ready for occupancy. In striking contrast to the old, dilapidated Ontario Street structure, the pristine headquarters partially rewarded the Chinese for the indignation they had suffered from their forced uprooting.

Numerous organizations in China donated ebony tables and chairs, drums and gongs, incense burners, silks, drapes, wall hangings, ceremonial umbrellas and other gifts. As the generous offerings arrived, On Leong Tong lawyers investigated possible legal loopholes to avoid duty charges. On January 4, 1931, about one hundred delegates from other cities joined nearly one thousand importers, merchants and restaurant owners in the formal dedication ceremony.

The new Rockwell Avenue headquarters housed first-floor retail shops and restaurants and second-floor apartments and offices. The third floor accommodated On Leong offices, meeting rooms and a stunning altar dedicated to Kwan Kung. The most famous general in Chinese history, Kung united the three kingdoms that now compose China. The Chinese later considered Kung the god of business.

On March 31, 1930, Louis Wo, president of On Leong Tong, broke ground for the new Rockwell Avenue headquarters. *Courtesy of Cleveland Public Library, Photograph Collection.*

Opposite, top: During the On Leong Tong's inaugural festivities, modern-dressed Lai Young Tend of Cleveland accepted a gift from Pittsburgh's Mrs. Yee King Lai, who is clad in traditional Chinese garments. *Courtesy of Special Collections, Michael Schwartz Library, Cleveland State University.*

Opposite, bottom: The beautiful altar elevated On Leong Tong's members' pride in the organization. *Courtesy of Special Collections, Michael Schwartz Library, Cleveland State University.*

A stunning meeting room and adjoining altar added beauty and elegance to the third floor of the On Leong Tong building. *Courtesy of Cleveland Public Library, Photograph Collection.*

Opposite, bottom: During the 1930s, a Rockwell Avenue worker subdivided a large tea shipment, imported from China, into smaller packages for resale. *Courtesy of Special Collections, Michael Schwartz Library, Cleveland State University.*

Many of Ontario Street's most venerable establishments followed the On Leong Tong's migration to Rockwell Avenue, in the process establishing the street as the heart of Cleveland's new Chinatown. Louie Wah, who had purchased the Sam Wah Yick Kee trading company in 1923, relocated his business even prior to the On Leong Tong's opening. Born in Canton, China, Wah arrived in Cleveland at the age of twenty-six. He and his wife operated the store together until her death in 1945. Remarried in 1951, his second wife worked as a seamstress in a nearby Bobbie Brooks garment factory. Wah's two arranged marriages resulted in eight children, six with his first wife. He and his second wife raised the family in an apartment located in the same building as the store. All eight children earned college degrees.

Through the decades, shoppers explored the tall wooden shelves of the Sam Wah Yick Kee store, uncovering unusual cooking ingredients such as

In 1935, an employee of the Sam Wah Yick Kee Company delivered new merchandise to the landmark Rockwell Avenue store. *Courtesy of Special Collections, Michael Schwartz Library, Cleveland State University.*

black fungus tree ear, imported from Hong Kong to add flavor to soups and chicken dishes. Agar-agar, produced from seaweed, added a crunchy texture to cold dishes and assisted the gelling of salads and desserts. One of the store's most unusual treats consisted of the eggs of duck, chicken or quail preserved in a mixture of clay, ash, salt, quicklime and rice hauls. The concoction morphed into a delicacy as the yolks turned dark green or gray while the egg whites changed into shadowy brown with a consistency resembling jelly. Called "thousand-year eggs," the transformation actually required only a few months.

Louie Wah and his family cultivated bean sprouts in the store's basement. After soaking peas in lukewarm water for eight hours, an ensuing four-day ritual required sixteen different rinses, each of these cleanings executed at carefully controlled water temperatures to produce the fresh bean sprouts. The store's imports consisted of bok choy, mustard greens, melon seeds, tapioca starch, snow peas, fresh bean curd, dried fish, cuttlefish, scallops and squid, along with lotus, tar and ginger roots. Cans of loquats, guava, banana blossoms and bamboo shoots also helped to fill the shelves.

A few doors to the east, Wah owned a noodle factory to supply restaurants with fresh noodles along with wonton and eggroll skins. By the 1970s, the business had grown into the state's largest supplier of Chinese restaurant food, selling to fifty eateries in Greater Cleveland, thirty other Ohio restaurants and twelve more in Pittsburgh. In addition to Chinese noodles, the company supplied bamboo shoots and water chestnuts imported from Taiwan. Even after passing the age of eighty, Wah continued his operation until three years before his 1988 death. None of his eight children or fourteen grandchildren chose to continue the business.

Chinese restaurants soon claimed spaces on the street level of the On Leong Tong building and nearby Rockwell Avenue storefronts. Hosting lunches and dinners for businesses, clubs, private parties, wedding receptions and fraternities and sororities, some of these restaurants remained destination eateries for decades.

Jessie Wong Ming, the daughter of early Chinese leader Wong Kee, established her reputation as a leading Ontario Street restaurant owner after three years of study at Ohio Wesleyan University. Relocating to Rockwell Avenue, her eatery developed into one of the most popular restaurants in the new Chinatown district. In addition to good food, patrons admired a décor highlighted by rice bowls imported from China and dinner plates manufactured in East Liverpool, Ohio. Attractive black wooden tables and chairs, fashioned with black marble panels on top and mother-of-pearl inlays,

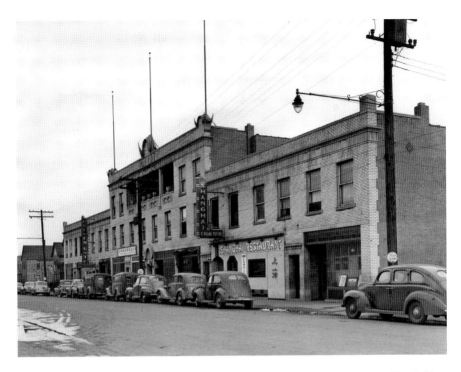

The Shanghai Restaurant (right) is pictured fourteen years after its 1931 debut. The Golden Gate Restaurant, which opened in 1933, is to the left. *Courtesy of Cleveland Public Library, Photograph Collection.*

further enhanced the dining experience. Born in Cleveland but educated in China, Ming actively participated in many social organizations and enjoyed singing at various community events.

The Shanghai Restaurant debuted in 1931. Head chef Tom Luck generated an immediate positive effect on the restaurant's business by demonstrating secrets of cooking chow mein, chop suey and sub gum at a local cooking and food exposition. Within a few years, Luck owned the restaurant. In 1940, he expanded by purchasing and integrating Jessie Wong Ming's next-door eatery into his Shanghai Restaurant.

Luck celebrated the restaurant's seventeenth anniversary by composing a Chinese ballad, which he titled "Tin Yen Chong You." Performing his composition on a four-string Chinese instrument, Luck claimed the title translated into English as "Dream of the Emperor's Wife." In the 1940s, lunches cost $0.35, while dinners sold for as little as $0.50. In 1954, the sequestered jury deliberating the world-famous Dr. Sam Sheppard murder case journeyed to the Shanghai for lunch, incurring a total bill of $13.30

for the fourteen-member party. Marketing to both Chinese and Americans, Luck advertised the Shanghai as a setting "where the Oriental gastronomical delight meets the palace of the Occidental."

The year the Shanghai Restaurant opened, eleven-year-old Tom Neay traveled alone from Canton, China, to unite with Tom Luck, his father. Neay later earned a civil engineering degree and acquired a national reputation as a designer of water supply, sewage disposal and industrial waste plants. In 1955, he joined his father as a partner operating the Shanghai Restaurant. After Luck's death in 1975, Neay continued to manage the restaurant. The Wu family acquired the Shanghai in 2009, but with the decline of Rockwell Avenue, the restaurant closed shortly afterward.

In 1931, Quong Lee launched a restaurant a few doors from Jessie Wong Ming's eatery. Seven years later, Mrs. Anna Garringer, a twenty-year-old transplant from Oklahoma, arrived in Cleveland. Two days after Anna secured a job as a waitress at Quong Lee's establishment, two robbers tied Anna and Quong with cord, gagged them with aprons and robbed the pair at knifepoint. Obsessed with Mrs. Garringer's beauty, the younger of the two culprits had difficulty concentrating on his criminal tasks as he continually stopped to kiss his startled and annoyed victim. Before fleeing with the twosome's money, he asked Anna for her address and telephone number, a request that she refused. Amazingly, the police never apprehended this very unconventional lawbreaker.

In 1933, Fong Foo Hong opened the Golden Gate Restaurant on Rockwell Avenue, although George Hin Jew managed the eatery until his 1943 induction into the army. Accompanied by a relative, Jew had immigrated to Cleveland at a very young age. When his relative died, the thirteen-year-old supported himself working in laundries and as a busboy prior to his Golden Gate employment. From 1959 until his 1974 retirement, Jew co-owned the Oriental Terrace Restaurant in the Southgate Shopping Center. On May 24, 1987, at the age of seventy-five, Jew died in St. Vincent Hospital following a heart attack.

In the mid-1930s, as the enmity between the On Leong and Hip Sing tongs ended, the former bitter rivals cooperatively raised money to transfer the remains of 120 Chinese immigrants, buried in Cleveland, back to their Chinese homeland so they could rest next to their relatives and ancestors. Bearing little resemblance to the On Leong Tong's conventions in the violent 1920s, a ten-day 1937 national gathering concentrated on the implementation of charitable work, appropriation of money for relief purposes, assistance to Chinese schools in the United States and

Without a local newspaper, Chinatown residents relied on a Rockwell Avenue bulletin board to obtain news and information concerning the neighborhood. *Courtesy of Special Collections, Michael Schwartz Library, Cleveland State University.*

the development of methods to promote cultural relations between the United States and China. The delegates conducted two daily four-hour sessions, the first beginning at 1:00 p.m. and the second at 7:00 p.m. Meanwhile, incense burned at the headquarters' altar while flowers, some imported from China, decorated the rooms. Also in 1937, the national Hip Sing convention, held in Cleveland, discussed money-raising methods to support a Sino-Japanese war relief fund.

In 1939, brutal violence reminiscent of the prior decade's tong wars briefly flared again in Cleveland's Chinatown. Merchants, restaurant owners and employees experienced aggressive pressure to purchase Chinese war bonds and contribute to relief funds for Chinese who had been injured or had lost property in the Chinese-Japanese war. Those unwilling to donate money risked physical beatings. Eugene Dar, two months delinquent in his compulsory contributions, and Fong Gong, four months in arrears, both suffered floggings with bamboo poles. Dar managed kitchens for downtown's Theatrical Grill, Backstage Club and Padlock Club, while Gong worked on

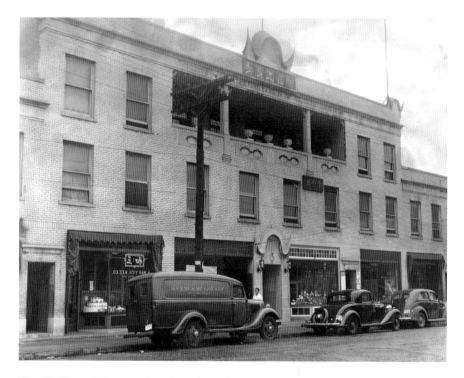

Two On Leong Tong members in 1939 endured loathsome beatings on the second floor of the headquarters building. *Courtesy of Special Collections, Michael Schwartz Library, Cleveland State University.*

a WPA project. On a beautiful August evening, ruffians abducted Dar on Chester Avenue near East Ninth Street and Gong on Euclid Avenue at East Seventy-ninth Street. Taken to the second floor of the On Leong building, the pair endured four hours of beatings. The thugs robbed Dar of nine dollars, while a friend paid ten dollars toward Gong's sixteen-dollar debt. The crimes remained unsolved, even though truck drivers witnessed the whippings while working in a terminal across the street.

The violence progressed beyond beatings. Two teens visiting Perkins Beach discovered the body of Wong Youn floating in Lake Erie with fractures to his skull and left leg, along with cuts and bruises to his face and chest. Youn, a Rockwell Avenue resident living above the Wah Hing Trading Company, had been a cook at the downtown Golden Pheasant and Lotus Garden Restaurants and a solicitor for one of the relief funds. Police suspected Youn's death had been related to his uncompromising demands for relief fund payments. Federal Narcotics Bureau agents investigated a possible connection between his death and a local opium ring. But Cuyahoga County

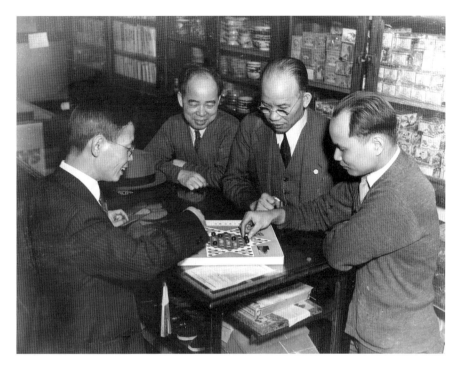

In 1939, community leaders Tom Chan Poy, Wah Louie, Fong Foo Hong and Toy Louie engaged in a game of Chinese checkers. *Courtesy of Special Collections, Michael Schwartz Library, Cleveland State University.*

coroner Samuel Gerber effectively closed the case when he concluded that the death must be ruled accidental since no irrefutable evidence of murder or suicide existed.

Aside from this incident and a few cases of isolated belligerence, the Chinatown neighborhood remained calm and continued to flourish. In 1940, Wing Chan founded the Min Sang retail grocery store. While importing food from China and Formosa, Chan grew bean sprouts in the basement of his store, selling his crop to grocery stores and restaurants. The Min Sang business remained a Rockwell Avenue fixture for fifty years.

In the early 1940s, the Chinese suffered through a wave of inane "Confucius say" jokes ranging from philosophical to demeaning (and later risqué): Confucius say man who wants pretty nurse must be patient; Confucius say he who throws mud loses ground; Confucius say the only place where success comes before work is in the dictionary; Confucius say the heaviest thing to carry is a grudge. A homebuilder's newspaper advertisement contained the headline, "Confucius say poor quality makes sweet price bitter." The May

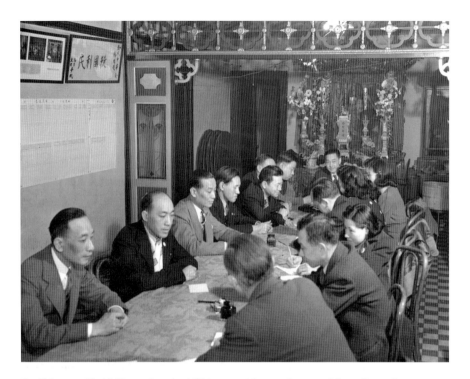

On February 16, 1942, one hundred Chinese residents volunteered for military duty at an induction center located in the On Leong building. *Courtesy of Special Collections, Michael Schwartz Library, Cleveland State University.*

Company's street-floor jewelry department even sold "Confucius say" lapel pins for one dollar.

Tom Chan Poy, president of the On Leong Tong, conducted an informal investigation to determine local Chinese reactions to the silliness. He concluded that most Chinese thought the jokes represented the spirit of good American fun. In fact, the Chinese even created their own version of the humor: "Confucius say man who makes dull jokes blames it on Confucius."

On December 7, 1941, Chinatown's residents congregated on street corners, huddled in doorways and gathered around radios, eager to obtain the latest news concerning Japan's attack on Pearl Harbor. Cleveland's Chinese leaders correctly foresaw Japan's downfall, which also ended the prolonged war between Japan and China. Businessman Louie Wah predicted the land of the rising sun would soon be in shadows and darkness.

Robert Thang, a thirty-one-year-old immigrant, became Cleveland's first Chinese resident to be drafted into military service. Entering the army, he mentioned his pride in serving a country that had given him so much.

Twenty-one-year-old Alvin Wong, a navy enlistee who lived on Rockwell Avenue, told reporters, "We want to go after them quick." One year later, Wong died during a training flight accident in Texas.

Tom Chan Poy, an adversary of Safety Director Edwin Barry during the 1925 Tong War, also volunteered for military duty. Poy had immigrated to the United States in 1908, later owning a tea business and the downtown Cleveland Far East Restaurant. In the 1920s, as a leader in the Chinese community and a Rockwell Avenue resident, Poy battled against tong war violence and criminals robbing Chinese restaurants. Turning to international issues in the 1930s, he established relief funds and other assistance to Chinese involved in the war with Japan. As an American citizen in 1941, Poy passed his army physical at the age of forty-three.

During the war, Reverend Martin M. Burke, a visiting priest from the Catholic Foreign Mission Society on leave from his work in China, conducted missionary work among the Chinese in Cleveland. Eighteen converts, baptized at St. John's Cathedral, included officers in the On Leong

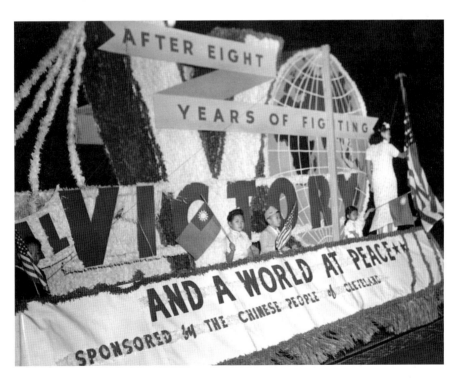

The Chinese community celebrated the end of the Second World War by participating in a Victory Day parade staged on September 12, 1945. *Courtesy of Special Collections, Michael Schwartz Library, Cleveland State University.*

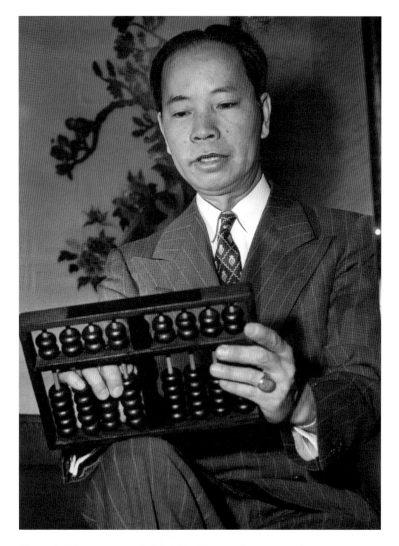

Howard Chin, manager of Chin's Red Dragon Restaurant, demonstrated the use of an abacus to schoolchildren on field trips to Chinatown. *Courtesy of Cleveland Public Library, Photograph Collection.*

Tong and restaurant owners and their employees. Although the Chinese adopted the Christian religion, time-honored customs survived through their incorporation into their new religion. At a christening ceremony, a Rockwell Avenue family welcomed their infant into the Catholic faith by rolling hard boiled eggs and rice over the baby's head; the eggs signified purity, and the rice endowed him with strength.

After the war, elementary school students journeyed to Chinatown on daylong field trips. The children inspected merchandise in gift stores while the owners recounted tales and legends pertaining to Chinese history and culture. During lunch at the Shanghai Restaurant, the staff instructed the students on how to use chopsticks. In the afternoon, other shop owners provided lessons in manipulating an abacus or described how tea and other herbs are used as medical alternatives. A visit to the On Leong Tong temple, where the students admired a statue of Buddha, completed the day's Chinatown adventure.

Spreading communist ideology in the late 1940s inspired Hong Kong and Taiwan residents to immigrate to the United States; a few of them migrated to Cleveland, increasing the city's Chinese population to almost nine hundred inhabitants.

In 1948, the national On Leong convention attracted 175 delegates from one hundred cities. Their concerns focused on combating the threat of communism in China and supplying money to the mainland. The group dispensed with the customary large banquets and instead consumed more modest dinners, contributing the differences in cost to relief efforts. Their only diversion from business and frugality consisted of entertainment by eleven members of the New York Chinese Opera Company. By this time, the On Leong had evolved into an association performing the functions of a bank, welfare institution, mutual benefit society and trade association. The organization granted cash advances to member businesses, death benefits to surviving families and care for the poor while also establishing standards and codes of ethics for its member businesses.

As the 1940s ended, Jack Jong Lee founded one of Rockwell Avenue's most famous restaurants. A college-educated teacher in China, Lee immigrated to the United States in 1924. He began his restaurant livelihood as a waiter in downtown Cleveland's Golden Pheasant Restaurant. Twenty-five years later, Lee and his wife, Wai Lan, also a native of China, welcomed the first diners to their Three Chinese Sisters Restaurant. The couple's three daughters (Mary, May and Betty) inspired the eatery's name; each played an active role in nurturing the family business into a destination restaurant.

Within a decade, the Lee family required a larger venue. In 1960, preparing to relocate a few storefronts to the east, Mary completed a two-month study program in a Hong Kong cooking school. During her trip, she purchased ornamental tapestries and screens, decorated in ivory and teak,

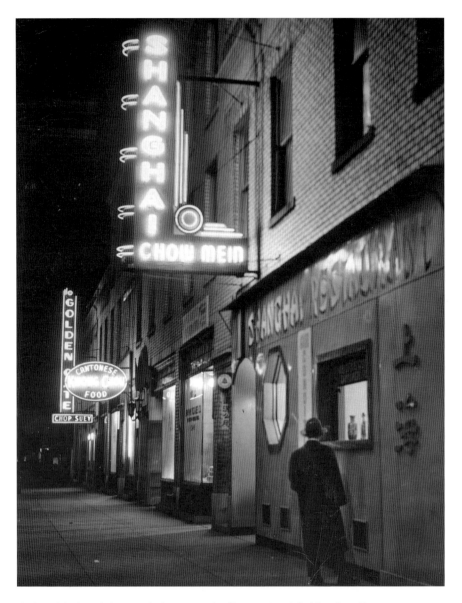

At the midpoint of the twentieth century, the Shanghai and Golden Gate Restaurants were the anchor tenants for Rockwell Avenue's Chinatown district. *Courtesy of Special Collections, Michael Schwartz Library, Cleveland State University.*

to embellish the new restaurant's interior. The eatery continued its policy of remaining open seventeen hours each day, seven days a week, from 11:00 a.m. to 4:00 a.m. the following morning. The Lee family lived

in the rear of the building housing the restaurant.

Just one year following the debut of the second Three Chinese Sisters Restaurant, May secured a position as a hostess in the new Kon-Tiki Restaurant located in the downtown Hotel Cleveland on Public Square. In 1966, with the family's blessing, May launched her own restaurant, a new version of the Golden Pheasant, just west of the Three Chinese Sisters. Now competing with her parents and two siblings, May recruited Harry Chung, her husband, as the head cook. The Golden Pheasant replaced the Golden Gate Café, one of Rockwell Avenue's most venerable restaurants.

Chinese immigrant Jack Jong Lee founded the Three Chinese Sisters Restaurant. *Courtesy of Cleveland Public Library, Photograph Collection.*

May carefully scrutinized the eating habits of her clientele. In a 1971 *Plain Dealer* interview, she concluded that American diners favored sub gum chow mein and sweet and sour pork, while Japanese patrons chose shrimp with lobster. Chinese enjoyed duck, especially relishing the crisp skin. Americans selecting the same dish peeled off the skin, never ordering duck again. In 1976, May and Harry embarked on a new endeavor, the May Chung Restaurant in South Euclid. New owners renamed the Rockwell Restaurant the Golden Coins, and it became a favorite eating spot of Engelbert Humperdinck when he performed at the downtown Palace Theater. The singer especially enjoyed chicken lo-mein, a chicken and mushroom stir fry served atop soft noodles. Along with Humperdinck, a wall containing pictures of notable personalities who had dined at the restaurant included Vice President Hubert Humphrey.

Meanwhile, the Three Chinese Sisters continued to thrive, even though the roles of Mary and Betty declined following their marriages and increased family responsibilities. After Jack Jong Lee's death in 1980, his son Andrew

Diners enjoyed a meal at the Three Chinese Sisters Restaurant about one year before its 1983 closing. *Courtesy of Cleveland Public Library, Photograph Collection.*

assumed management of the restaurant. Notwithstanding the restaurant's name, Andrew had been employed as a cook in the family business while attending East High School. After earning a combined degree in physics and business from Case Western Reserve University, he worked for fourteen years as an agent for the Social Security Administration in Ashtabula. Three years after his father's death, the thirty-five-year-old Andrew also died. His untimely passing ended the Three Chinese Sisters' successful thirty-five-year existence on Rockwell Avenue.

The blending of Asian and Cleveland cultures continued in earnest. In 1954, a front-page article in the *Cleveland Press* heralded the unprecedented arrival of seven graduate scholars from Taiwan into Case Institute of Technology's engineering studies; one student later joined the school's faculty. Three generations later, Beijing dethroned Cleveland as the home city to the most number of students attending Case Western Reserve University. Shanghai jumped to third position, followed by Solon, Pittsburgh and San Jose. In total, the university's student body consisted of scholars from eighty-four nations.

By 1966, the Sam Wah Yick Kee Company had operated on Rockwell Avenue for nearly four decades. *Courtesy of Special Collections, Michael Schwartz Library, Cleveland State University.*

At a 1951 Hip Sing national convention in Cleveland, attendees developed procedures to send financial aid to nationalist strongholds in Formosa. About 160 members attended the 1961 On Leong national convention that began with the exploding of ten thousand firecrackers. The meeting concentrated on improving methods to arbitrate debts and disputes between national members, a process sometimes necessary since Chinese generally conduct business without written contracts.

By the end of the 1960s, Rockwell Avenue's Chinatown consisted of three restaurants and two grocery stores. In the next decade, Richard Nixon's pioneering visit to China inspired a renewed American interest in Chinese food, especially the expensive and exotic-sounding shark fin soup, which Nixon sampled. The soup, symbolizing wealth, power, prestige and honor, is usually reserved for important business and political meetings, as well as exclusive weddings and banquets. A host serves shark fin soup to demonstrate respect, honor and appreciation to guests. Capitalizing on Nixon's trip, the Three Chinese Sisters Restaurant created a special eight-course dinner, priced at ten dollars, which included a bowl of shark fin soup.

Although a pricey luxury, the practically tasteless shark fin is used mostly to provide texture; the soup's actual taste is derived from chicken, ginger root, spring onion, wine, soy sauce and other ingredients. But in Asian cuisine, texture is valued as much as taste.

For centuries, removal of shark fins had involved an inefficient and later illegal procedure that disregarded the remainder of the shark's body. But by the time of Nixon's visit, shark killing had evolved into a highly resourceful industry. West Coast fishing interests, inspired by supply problems during World War II, turned shark hunting into a low-waste industry. Primarily established to obtain vitamin A from shark's liver, Americans created a use for nearly every part of the captured shark; skin for leather, teeth for costume jewelry, meat for restaurants, flesh for animal feed, jawbones for decorative figurines and fins for soup.

The Nixon visit introduced the exotic soup to a generation unaware of the delicacy's popularity in the 1930s. As some Cleveland citizens lingered in soup lines during the Great Depression, elite social clubs and organizations indulged in fresh shark fin soup at luncheons and dinner meetings, such as a 1936 Women's Club event in the Bulkley Building. The downtown Higbee department store even sold a packaged variety of the soup in a street-level grocery department.

By the 1970s, both the On Leong and Hip Sing associations eliminated the word "tong" from their names. The 1973 On Leong national convention welcomed 330 delegates and visitors.

A common culture unified the Chinese in tightknit communities, first on Ontario Street and then on Rockwell Avenue. The On Leong headquarters continued to unite the Rockwell Avenue neighborhood for decades. Instead of relying on juvenile court judges, parents settled their children's disciplinarily problems. The Chinese community took responsibility for assisting their unemployed, caring for their sick and needy members and

passing their rituals and heritage on to new generations. Yet Rockwell Avenue's Chinatown district seemed to decline each year. With the passing of time, many Cleveland Chinese Americans acquired college degrees in science, engineering, medicine, law, architecture and other professional fields. Scholars conducted research and became professors at Case Western Reserve University, Cleveland State University and other schools. The Chinese continued their path toward Americanization by purchasing homes in wealthy suburbs. By 1985, 250 Chinese restaurants operated in Cleveland and its suburbs; only 2 of those eating spots remained on Rockwell Avenue. As fewer new immigrants arrived, membership in the On Leong Association plunged from 400 in 1990 to about 100 a decade later.

In 1990, a five-month crime wave shocked the neighborhood. An intruder wielding a large knife entered and robbed two East Thirty-sixth Street homes and another on East Forty-fifth Street. Three men, wearing Halloween masks and carrying guns and a butcher knife, robbed the Far East Gift Shop on Rockwell Avenue next door to the Wah Hing social club. Within two weeks, robbers targeted the club itself as gunmen wearing ski masks stole money from Chinese enjoying a game of mahjong, a form of dominoes. When Jonathan Mar motioned to his father, who did not speak English, to lie down on the floor, one of the criminals shot Jonathan in the back. The bullet passed through his liver, bruised a kidney and missed his spinal cord by about one inch, but he recovered from the shooting. Next, a customer leaving the Shanghai Restaurant became the victim of a mugging. The 1991 debut of Asia Plaza on Payne Avenue drained the final life from the Rockwell Avenue community. By the end of the twentieth century, Cleveland's old Chinatown might have more aptly been characterized as a ghost town.

The On Leong organization admitted its first female members in 2000. Its membership book, now nearly a century old, is still updated by hand using Chinese characters. A Buddhist temple, organized in 2009 by a group of Taiwanese, debuted above the former Shanghai Restaurant. The temple embraces Taoism, Confucianism and Christianity.

In 2013, the distressed Rockwell Avenue exhibited its first serious signs of revival. The On Leong Association sold its building to a group of Chinese investors but remained a tenant. Attracting funds from local sources and mainland China, the building has experienced a beautiful restoration. Chinese investors opened the Emperor's Palace, arguably Cleveland's most plush Chinese restaurant, which tastefully combines sparkling chandeliers, red and gold décor and decorative ornamental woodwork. Renovated upstairs apartments are marketed to Chinese students at Cleveland State

Above: Rockwell Avenue's Emperor's Palace is one of Cleveland's finest Chinese restaurants. *Courtesy of the author.*

Left: A hand-carved stone dog, manufactured in Guangdong, is one of twelve zodiac symbols now watching over a Rockwell Avenue parking lot in front of the On Leong building. *Courtesy of the author.*

University. Future plans call for more restaurants, a museum devoted to local Chinese history, a fish market and a gift shop. Rockwell Avenue is now branded as Historic Chinatown.

The story of Rockwell Avenue's Chinatown would not be complete without mention of the non-Asian Rockwell Inn. In 1946, the restaurant opened on East Twenty-first Street, debuting as the Express Grill. Jack Kackloudis and his sons (Steve, Nick and Mike) created a first-rate steakhouse as an alluring alternative to the Chinese restaurants in the neighborhood. Jack died in 1957. After selling the Express Grill in 1965, Nick and Steve relocated directly around the corner to Rockwell Avenue in the same strip as the Chinese restaurants; Mike chose to enter the hairdressing business. One year later, Nick expanded his resume by playing the lead role in a musical version of *Dracula* at a summer theater in Ravenna.

The Express Grill and Rockwell Inn served as hangouts for local newspaper reporters and staffs. National columnist Dorothy Kilgallen, visiting the city during the Dr. Sam Sheppard murder trial, devoted a column to the restaurant entitled "There's a Tavern in the Town." Bob Considine praised the eatery in several articles. Regular customers included Cleveland Indians' owner Gabe Paul, pitcher Early Wynn and Jimmy Dudley, the legendary baseball announcer. During the restaurant's long run, entertainers Danny Thomas, Andy Griffith, Anne Baxter, Celeste Holm, George Maharis, Frank Fontaine, Pat Paulsen, Sebastian Cabot, June Wilkinson and numerous others dined at the grill. In 1969, Steve died at the age of forty-five. In 1977, Nick sold the Rockwell Inn, which continued in business into 1988 offering entertainment composed of folk and blues singers and exotic dancers.

6
Celebrating Asian Culture

Lunar New Year and Moon Festivals

Based on a lunar calendar, Chinese New Year arrives on the day of the second new moon following the winter solstice, no earlier than January 21 and no later than February 19. In the late nineteenth century, feasting, singing, praying and abstaining from work began thirty days prior to the actual New Year's Day, with each succeeding day's revelry increasing in energy. Businesses sometimes closed for days at a time. Only laundries, fearing the permanent loss of customers, maintained punctual business hours.

During the joyful season, friends, family and neighbors visited one another's homes. To prepare for these gatherings, homemakers thoroughly cleaned their houses and polished furniture and floors. In addition to honoring guests by presenting homes to their best advantage, the cleaning helped sweep away bad luck from the previous year. Homemakers always brushed dirt inward toward the center of the room and removed the grime through the back door. Getting rid of dirt through the front entrance might sweep away the good fortune that would have otherwise occurred in the following year. On occasion, friends modified the typical "happy new year" salutation with a welcoming to reflect individual circumstances. A person suffering from poor health might receive a "healthy new year" greeting, while another in adverse financial conditions would be wished a "prosperous new year."

Since excellent food is an important indication of hospitality, guests sampled treats from nearly overflowing tables filled with oranges, preserves and candy. Chinese in the United States modified an ancient custom of

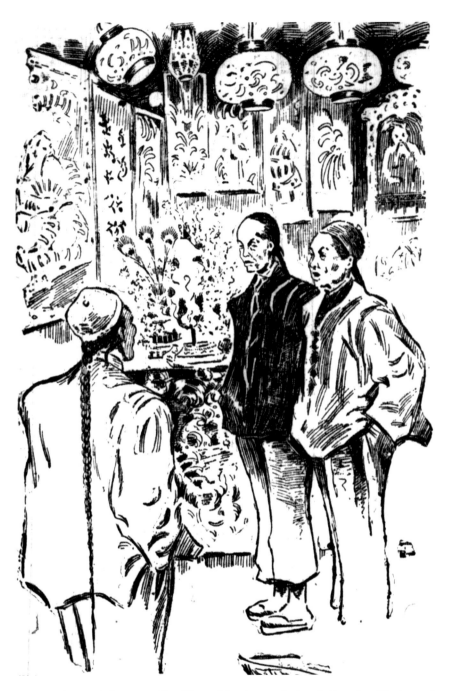

In the early twentieth century, New Year celebrations took place in Peter Len Ling's temple. *Courtesy of the* Plain Dealer.

offering visitors a pipe of tobacco by substituting, if the guest desired, an American cigar. Married relatives presented red envelopes to their unmarried family members, each initially filled with coins and later with crisp, folding money. Bowls of food placed in backyards served as offerings to ancestors.

The entire community participated in the holiday merriment. Business owners decorated their establishments with Chinese flags and bunting highlighted with dragon pictures. Owners placed a table filled with tea, rice brandy, candied fruit and nuts in front of each shop when it remained opened for business. Grocery stores erected temporary altars to Confucius. During the holiday season, Chinese repaid all of the debts incurred during the year.

In the late 1880s and into the 1890s, on the eve of the New Year, local Chinese and others drawn from nearby towns journeyed to Peter Ling's Woodland Avenue temple wearing their best brilliantly colored silk clothing. As odors of incense and cigars pervaded the neighborhood, exploding firecrackers provided enjoyment while, according to tradition, chasing away evil spirits. Clanging gongs and clashing brass cymbals, some three feet in diameter, provided the accompaniment as flying rockets shot into the air before bursting into myriad colors. In many respects, the New Year celebrations incorporated many aspects of multiple American holidays: family gatherings (Thanksgiving), giving of gifts and religious observances (Christmas) and firecracker eruptions (Fourth of July).

In 1889, the city banned the use of firecrackers during the New Year festivities. In addition to eliminating the fun and excitement created by the explosives, the frustrated Chinese foresaw the arrival of bad luck in the coming year. According to legend, wicked spirits could be driven away only by noise as loud as the simultaneous explosion of thousands of firecrackers. The clamor sent the dreadful demons galloping toward the setting sun, which consumed them. Sam Lee, operator of a laundry on West Sixth Street, registered a very practical protest. He complained that San Francisco, unlike Cleveland, provided plenty of both firecrackers and whiskey for its celebration. The ban also seemed particularly unjust since no comparable restriction existed for Americans commemorating the Fourth of July. Although lacking a vital element in their celebration, the community continued the customary feasting and good cheer throughout the prolonged holiday period.

Firecrackers returned in 1899 as celebrations briefly shifted to the Chinese Masonic Lodge on West Third Street. A lavish banquet featured steaming hot chicken and pork along with bird's nest soup, a delicacy consumed by

In 1910, firecrackers set off near an Ontario Street grocery store provided enjoyment while also scaring off evil spirits. *Courtesy of the* Plain Dealer.

Chinese for more than seven hundred years. The soup's name refers to the hardened saliva created by cave-dwelling birds that paste their nests together using their own spit, which solidifies when exposed to air. Searchers experience difficulty in locating and capturing the nests, often built high on the sides of perilous cliffs. These obstacles add to the soup's mystique and expense. The extracted saliva, after being cleaned of feathers and debris, constitutes the soup's most integral ingredient. A *Plain Dealer* reporter once described the soup as resembling stringy glue. Although often appearing unappetizing to the Western world, the saliva supposedly improves skin tone, helps maintain a youthful complexion, stimulates both appetite and digestion, wards off tuberculosis and speeds recovery from chronic illnesses and malaria. A single serving of bird's nest soup would have cost $2.50 had it not already been paid for by the sponsoring Chinese fraternal organization.

By the twentieth century, rising costs had curtailed the festivities from one month to one or two weeks. Celebrations shifted to Ontario Street, where they remained for three decades. During the 1900 holiday season, restaurant proprietor Huie Gimm died of consumption. Living his last eighteen years in Cleveland, Gimm had developed many friendships. The death dampened the community's festive spirits partly because a significant death during the holiday season created a bad omen for the following year.

In 1905, the Chinese received their first permit to celebrate the New Year on Cleveland's streets. Elated with their new opportunity, they attached 600,000 firecrackers to a forty-foot-long string hanging from the roof of the Hong Kong Low Restaurant on East Ninth Street. The *Plain Dealer* described Cleveland's largest firecracker extravaganza, up to that point, as sounding "like a battery of Gatling guns in action." Following the blast of the last firecracker, the street lay strewn with red paper, an aftermath of detonating the noisy explosives.

Since no official place existed to pay respect to Confucius, restaurant owner Wong Kee placed a large picture of the patron saint behind a temporary altar covered with incense jars, chickens, bowls of rice, fruits, nuts, candies, preserves, cups of tea, wines, cigars, flowers and wisteria blossoms and vines. Red and yellow paper, painted with birds and trees, decorated the walls of the short-term place of worship. Multicolored silk curtains, gold-embroidered table covers, decorative silver candle sets, brightly colored lanterns and sacred Chinese lilies also adorned the restaurant's area of reverence.

New Year celebrations often closed with a rite conducted in a beautifully garnished lecture room at the Old Stone Church, decorated with lanterns, rich silk hangings, potted plants, ferns and cut flowers. The service started

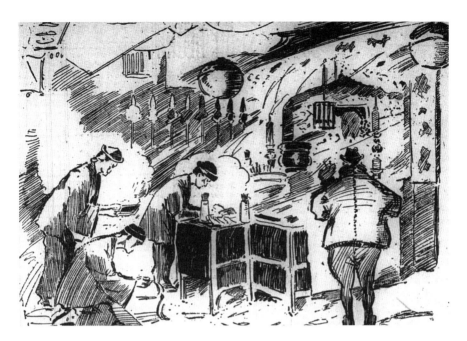

Prayer, contemplation and the offering of food constituted a major portion of the religious observation of the New Year. *Courtesy of the* Plain Dealer.

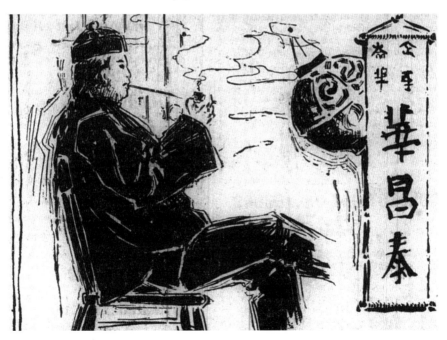

Anticipating a forthcoming New Year feast, an Ontario Street resident enjoyed a smoke from a long tobacco pipe. *Courtesy of the* Plain Dealer.

at 7:30 p.m. and sometimes continued for three hours. A typical ritual began with hymns sung in English and led by the Sunday school class. Next, a Chinese-language portion incorporated a singing duet followed by an address from a missionary. Sunday school students then recited verses from the Bible, in English or Chinese, depending on their comfort level. The service concluded with the showing of stereopticon views illustrating important biblical events.

Superstitions influenced many events occurring on the actual New Year's Day. Bad fortune in the next year could be swept, washed or cut away by removing dirt, rinsing hair or using knives or scissors. Although New Year's Eve meals did not include meat, one restaurant each year served as the focal point for an enormous feast a few days after the actual holiday. Non-Chinese did not receive invitations to these private parties until 1905, when political leaders, influential lawyers and other chosen professionals joined the merriment. In addition to the lavish banquet, each guest received a souvenir pair of chopsticks and a silk Chinese flag. In 1907, one of the first attempts to commercialize the holiday occurred when the Empire Theater presented a burlesque show titled *Wu Ting* during the holiday season.

Through 1910, Wong Kee had hosted thirteen consecutive celebrations at his various restaurants. Evolving into twenty-course meals, the banquets featured candied fruits, oysters, lobster salad, shark fins pickled in vinegar, fish, chicken chop suey, geese gizzards, turkey, egg omelets, cake, meat pie, lichee nuts, lily seeds, water chestnuts, bamboo shavings, mushrooms, candy, ice cream and champagne. Chinese also enjoyed traditional bird's nest soup and gum boi, a potent wine produced from fermented rice. Fish maw, another special treat, is the cooked gas-filled sac used by some species to control their buoyancy. Musicians accompanied the feasts by playing instruments, all imported from China, consisting of shrill-sounding two-stringed violins and cellos, bamboo flutes, reeds, wooden drums and tom-toms of various tones and sizes.

Different food offerings, each associated with a desirable trait, played an important role in the festivities. Noodles symbolized long life, unless they happened to be cut, which might achieve the opposite effect of shortening life. A whole fish signified abundance, while chicken suggested knowledge and prosperity. In America, green vegetables (resembling money) also evoked prosperity. In the same vein, egg rolls suggested gold bars, and mushrooms brought to mind coins. Pig's feet suggested easy money, such as winning a gambling lottery, while pork hinted at perfection. Tangerines helped fulfill wishes; lobster implied good health and happiness.

In 1911, the New Year celebration included worship at this altar in the temporary Ontario Street headquarters of the On Leong Tong. *Courtesy of Cleveland Public Library, Photograph Collection.*

In 1911, for the first time in the city's history, rival tongs conducted separate New Year celebrations. The Wong Kee Tong rejoiced at the Golden Dragon Restaurant on Public Square, while the newly formed Hip Sing Tong chose

the Emperor Restaurant on Superior Avenue, east of the Hollenden Hotel. The following year, Sun Yat Sen assumed a temporary position as president of the new Chinese Republic. In America, the Chinese disregarded one of his first edicts: the adoption of the American calendar with New Year's Day celebrated on the first day in January. In 1915, Cleveland mayor Newton D.

Rockwell Avenue residents Pauline Ming (age five) and Phyllis Wong (age two) assisted in the preparation of a firecracker display for the 1931 New Year celebration. *Courtesy of Special Collections, Michael Schwartz Library, Cleveland State University.*

Baker reinstated a short-lived ban on firecrackers. In hopes of still somehow intimidating evil spirits, Chinese piled stacks of the unused explosives around their altars but really didn't expect a positive outcome. As one worshiper lamented, "The ghosts cannot see, they only hear."

In 1930, New Year festivities ended on Ontario Street. A final subdued revelry reflected the absence of many residents who had already vacated the neighborhood in anticipation of its imminent demolition. A dwindling number of professional musicians forced a Chinese orchestra to substitute amateur drummers and gong and string instrument players. Former two-week celebrations had been reduced to only a few days, and many participants had replaced their traditional costumes with American clothing. Old-timers lamented that the present-day merriment didn't match that of past years. But the quality of the festivities improved greatly the following year on Rockwell Avenue.

Commemorating Chinatown's move to Rockwell Avenue, the 1931 celebration constituted the most elaborate New Year festivity to date. A one-inch-deep pile of red paper remained on the street following the huge firecracker extravaganza. As part of the two-week celebration, invited Westerners savored a banquet at the downtown New China Restaurant, where two Chinese singers warbled popular American songs in English. The On Leong Association began a tradition of opening its temple to the general public, but only on New Year's Eve.

During the Great Depression and World War II, On Leong members prayed for sales increases in their businesses and for the defeat of Japan. A few firecrackers thrown from the balcony of the On Leong Association constituted the only obvious merriment during uncharacteristically quiet celebrations. Magnificent feasts existed only in memories as fat choy (seaweed) with foo ho (dried oysters) composed the highlight of scaled-down banquets. The Hip Sing Tong offered a solitary bowl of rice at its holiday festivities. Only the most formal religious observations remained unaltered. The On Leong and Hip Sing organizations used their unspent funds to support unemployed members. While Chinese remained almost nonexistent on Cleveland's Depression-era relief rolls, organizations provided needed assistance to out-of-work individuals. Near the end of the Great Depression and continuing into World War II, the associations contributed to relief funds for the war-stricken mainland China population in its conflict with Japan.

As lavish complimentary banquets ended during this period of austerity, individual restaurants promoted their own distinctive dinners. In 1938,

In 1937, Mrs. Tong Y. Chin, Mrs. Louie Woo and Mrs. George Louie, wives of three influential Chinatown businessmen, are prepared for a scaled-down, Depression-era New Year festivity. *Courtesy of Special Collections, Michael Schwartz Library, Cleveland State University.*

Ben Lim, veteran restaurant owner and officer in the On Leong Tong, tested wonton soup while preparing for the 1951 Chinese New Year. *Courtesy of Cleveland Public Library, Photograph Collection.*

Chin's Red Dragon Café crafted a New Year menu composed of sub gum chow mein cooked with bean sprouts, bamboo shoots, water chestnuts and almonds, served with steamed rice and tea, for twenty-nine cents. For more traditional American tastes, a comparably priced selection featured roast loin of pork served with dressing, applesauce, French-fried or mashed potatoes, rolls and butter. World War II curtailed food imports, so bags of Chinese

Tong Y. Chin joined three of Jack Jong Lee's children (Mary, Andy and May) in contributing music to the 1954 New Year celebration. *Courtesy of Cleveland Public Library, Photograph Collection.*

candy, pastry and nuts substituted for many of the home-cooked New Year dinners in residents' homes. In 1947, full-scale celebrations returned to uplift the community and renew the assaults on evil spirits.

In 1950, the advent of television created subtle changes in New Year activities. Mrs. Ben Lin, wife of a restaurant owner, explained Chinese holiday traditions to a growing number of families who owned television sets. The locally produced newscast aired on WNBK (Channel Four), the forerunner to the current WKYC (Channel Three). The station had been in existence for less than eighteen months when Mrs. Lin used the new media to publicize Chinese customs. Meanwhile, families opening their homes to guests during New Year celebrations allocated a semi-private room to older visitors who enjoyed conversing without distractions from the new scientific wonder.

Long-established traditions remained an integral part of the Chinese New Year culture. Celebrations carried on for fifteen days; visits from relatives and friends continued, and children still looked forward to red envelopes filled with money. The On Leong Association slightly modified ancient rituals

by incorporating a few new aspects: the third-floor temple now displayed a large picture of Chiang Kai-Shek, recorded Chinese opera music played from speakers and colored lights illuminated the altar. Using a second-floor

Tom Woo, caretaker of the On Leong building, joined Chinatown restaurateurs Tong Y. Chin and Mary Lee in celebrating the 1960 New Year. *Courtesy of Cleveland Public Library, Photograph Collection.*

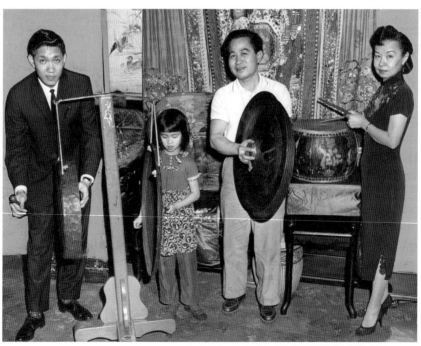

room remodeled to resemble an Asian temple, the Red Dragon Café staged native music concerts as part of its celebrations.

While the Rockwell Avenue community remained steeped in its traditions, Westerners discovered the commercial value of Chinese New Year festivities. During the holiday season, newspaper and magazine food columnists published Chinese recipes to use in home cooking. Chun King and La Choy, American manufacturers of canned and frozen Chinese food, initiated newspaper and radio advertising in select cities, including Cleveland, to promote their products. Chun King created a mail offer to purchase Chinese-styled lounging pajamas ($3.50 to $4.50 a pair, depending on the size) so the entire family could dress up and enjoy a festive Chun King New Year meal in their own home. The company suggested a three-course dinner comprising frozen egg rolls to complement canned noodles and chow mein.

The media used a more exciting style in describing each ensuing New Year. In the past, the media might have portrayed the Chinese year beginning in 1960 as the year 4,658 (equivalent to an ancient calendar) or the year 2,511 (matching a reform calendar) or the year 50 (corresponding to the birth of the new republic). But as 1960 approached, the year acquired a more simplistic and rousing description based on the Chinese zodiac: the year of the rat.

The zodiac animals introduced Western culture to elements of rudimentary Chinese astrology. According to a twelve-year zodiac cycle, a person's year of birth determines distinctive personality traits. People born in the year of the rat are adaptive, aggressive and creative. Ox years are allied with steadfastness, diligence and strength. Similar associations are the tiger (strong, courageous and alert), rabbit (peaceful and benevolent), dragon (ambitious and risk-taking), snake (changing and rejuvenating), horse (energetic and enduring), goat (creative, intelligent and dependable), monkey (mischievous and clever), rooster (industrious and diligent), dog (loyal and dedicated) and pig (gallant, wise, honest and fertile). The Vietnamese zodiac differs from the Chinese only by replacing the rabbit with a cat.

Opposite, top: During the 1960 New Year festivities, Chinese offered food to the God of Peace. Twelve-year-old Allen Wing demonstrated the second phase of this ancient custom by feasting on some of the offerings. *Courtesy of Special Collections, Michael Schwartz Library, Cleveland State University.*

Opposite, bottom: Alan Fong, Helen Louie (age seven), George Fong and Mrs. Ben Lin prepared for the 1960 New Year celebration. *Courtesy of Special Collections, Michael Schwartz Library, Cleveland State University.*

Personalities are also influenced by a second cycle consisting of the five elements of Chinese astrology: wood (assertiveness and anger), metal (guarded and aloof), fire (passionate and outgoing), earth (nurturing and sympathetic) and water (yielding and flexible). Thus, a person born in the year of the water tiger, which occurs once every sixty years, should display a mixture of strength, courage and alertness while also being yielding and flexible.

Yin and yang, the balancing of seemingly contradictory extremes, such as night and day or hot and cold, are also believed to shape personalities. Yin personalities (described as right-brain dominant in Western culture) are creative and emotional. Yang personalities (left-brain dominant) are logical, serious and organized. Since each zodiac animal is primarily associated with only one of the yin or yang characteristics, the cycle in not extended beyond sixty years. Thus the year of the yang fire rat occurred in 1936 and 1996 and will return in 2056.

Each zodiac animal is also assigned a specific lunar month as well as year. The pig, for example, governs the tenth month. A person born in the month of the pig will inherit attributes of that animal regardless of his or her year of birth. Even a more detailed analysis is possible because each day is divided into twelve two-hour segments, each dominated by a different zodiac animal. The pig rules the time between 9:00 p.m. and 11:00 p.m. Accordingly, the year, month, day and hour of a person's birth all contribute characteristics that combine to form an individual's personality.

A growing number of non-Asians, even though not generally versed in the serious religious segments of the festivities, still enjoy the good food and revelry linked with Chinese New Year. In the 1960s, New Year festivities incurred minor modifications that remain to the present day. All of the On Leong members dressed in business suits rather than native costumes. Chinese constituted only about one-quarter of those attending the Rockwell Avenue celebrations; although Asians from other countries joined the festivities, non-Asians made up the majority of the partygoers. Meanwhile, individual Chinese restaurants throughout the area created and promoted their own special New Year menus. The suburban China Gate Restaurant on Cedar Road advertised "free gifts for the ladies." Lion and dragon dances expanded into family tourist attractions.

In 1971, the Three Chinese Sisters Restaurant created a special New Year's Eve menu consisting of bird's nest soup, stuffed boneless chicken, fried rice (with ham, chicken and shrimp), chow min yang (beef with noodles), tim shun yu (sweet and pungent fish), lung fung kew (lobster meat with chicken and vegetables), a fruit bowl, wan fu (Chinese-style dry white wine), tea and

In 1964, Betty Lee (one of the Three Chinese Sisters) greeted a familiar visitor. A half century later, lion dancers continue to make annual visits to Cleveland's AsiaTown. *Courtesy of Cleveland Public Library, Photograph Collection*.

a fairly obscure addition to the Cleveland Asian food scene—dim sum (then described as a steamed pork-filled bun). Forty years later, comparing dim sum offerings at different restaurants turned into a routine pastime among

A capacity crowd enjoyed the Three Sisters Restaurant's 1968 New Year dinner. *Courtesy of Special Collections, Michael Schwartz Library, Cleveland State University.*

Cleveland foodies. The 1971 dinner, served to parties of eight or more, cost $7.50 per person.

The Golden Pheasant Restaurant charged the same price for chicken with white fungus soup, sue mine (a meat-filled steamed bun), a shrimp roll, fried rice (with chicken, ham, shrimp and roast pork), roasted chicken white meat served with a cherry garnish, chum mein (pan-fried noodles with vegetables and meat), fungus crab ding (diced crab with Chinese mushrooms, peas and dried white fungus) and sweet and sour fish kew. The Shanghai Restaurant created individually designed specials costing sixty-five dollars per table of ten.

By the 1980s, many mainstream organizations promoted Asian New Year activities. Cleveland State University initiated a daylong Asian cultural event that quickly expanded into two days. The Cleveland Public Library developed its own gala, while the Cleveland Museum of Natural History sponsored an Asian New Year's Eve party.

The lion dance, a traditional Asian ritual executed to frighten evil spirits, became a routine event at New Year celebrations, not only within the Chinese community, but also in suburban restaurants and libraries. While a goal of the lion dance is to induce good luck by eradicating malevolent spirits, viewers of the ceremony might expose themselves to the opposite result if the performers stage a poorly executed routine. Consequently, demand for very experienced lion dance teams accelerated as the ritual increased in popularity. Although

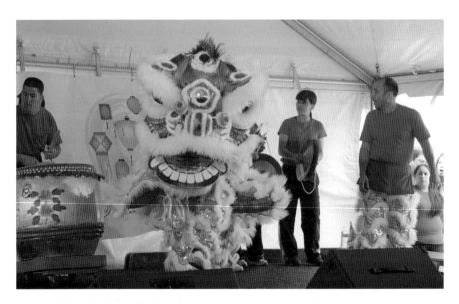

The George Kwan dance team is Greater Cleveland's most famous lion dance company. *Courtesy of the Cleveland Asian Festival and Trish Uveges.*

martial arts professionals and dance groups perform lion dances, the George Kwan dance team is Cleveland's most sought-after company.

In 1936, George Kwan, a Chinese immigrant, arrived in Cleveland at the age of fifteen. After participating in lion dances since his teen years, in about 1980, Kwan founded his own dance team anchored by family members. His three sons—George Jr. and Gregory, both policemen, and Gordon, a firefighter—performed with their sister, Gam, a service representative. Gam's husband joined the group, as did their daughter when she reached the age of fifteen.

As interpreted by Kwan, the lion begins the dance by bowing three times to demonstrate his humility. As team members beat drums and clash cymbals and gongs to depict various moods of the lion, three dancers in a twelve-foot tubular costume move slowly to indicate sleepiness, erratically to depict playfulness, methodically to simulate the pursuit of prey and violently to indicate the conquering of its victim. One person powers the head and keeps the mouth in motion; the other two dancers follow his lead. Dancers and musicians seamlessly switch positions during the twenty-minute (and sometimes much longer) routine. A fresh dancer enters the lion's tail to replace a tired performer who simultaneously jumps over or rolls away from his replacement. As the dance continues, audience members place red envelopes filled with money into the lion's mouth to show their appreciation and to bring them prosperity. In 2004, George Kwan died at the age of eighty-one, but family members have continued the performances of this much-lauded troupe into the present day. In 1990, Rockwell Avenue merchants added a dragon dance in which a dance team imitates the hypothetical undulating movements of the dragon.

In the twenty-first century, several AsiaTown locations vied for the increasing New Year holiday business. In addition to firecrackers and lion dances, the Li Wah Restaurant added an Asian fashion show, Japanese Taiko dancers, Chinese sword dancers and acrobats, martial arts demonstrations and Chinese bingo. Asian Town Center, a newer mall located on Superior Avenue, countered with a talent show, eating contests, children's activities, a Mongolian Bowl Dance, Bollywood dancers and Chinese hip-hop performers to augment their lion dance and martial arts routines.

As interest in Asian culture increased, the Feast of the Moon, a harvest festival, commanded attention among Westerners. Celebrated on the fifteenth day of the eighth lunar month (a time when the moon reaches its maximum brightness), the feast usually takes place in September. The event's culinary highlight is consuming moon cakes—small, round cakes

At Angkor Jewelry in Asia Plaza, this cooked pig will soon be devoured by customers during the 2014 New Year celebration. *Courtesy of the author.*

traditionally filled with lotus seed and a salty yoke in the middle to symbolize the full moon. Today, moon cakes have evolved into treats filled with fruit, dates and nuts, similar to fruitcakes.

Observed in China for hundreds of years, the feast gained special significance in the twelfth century when the Chinese used moon cakes to pass messages to assist in organizing an uprising against their occupation by Mongolians. In 1969, the moon festival received attention in the United States when the Chinese government invited the three astronauts who participated in the first moon landing to the festival in China. By the 1980s, Cleveland State University and the Holden Arboretum had staged annual moon feasts. In the next decade, the Hunan Gourmet on Euclid Avenue created a moon festival comprising food, martial arts demonstrations, a magician and a comedian. The Bo Loong and Li Wah Restaurants followed with their own festivities, as did Asian Town Center.

Chinese Decoration Day is observed on the 104th day following the winter solstice. The holiday, usually taking place in early April, is a time when Chinese remember and honor their ancestors. In the late nineteenth century, since few Chinese forebears had been buried in Cleveland, graves of cousins or friends substituted for those of parents or grandparents. Celebrants

decorated graves, many located in Woodland and West Park Cemeteries, with flowers, fruits, rice bowls, fish, cooked chicken, duck and an occasional stuffed pig.

In the first decade of the twentieth century, Cleveland's Chinese population also actively participated in two non-Eastern holidays: Christmas and the Fourth of July. Native Clevelanders had already developed an interest in exchanging Chinese-oriented Christmas gifts ranging from embroidery to teakwood tables. By the early 1900s, Chinese who had converted to Christianity considered the holiday personally meaningful. Others merely enjoyed a day off from work and the pleasure of exchanging gifts, such as elaborately embroidered handkerchiefs or pieces of jewelry. In business settings, merchants presented Christmas gifts to their customers, and restaurants created special Christmas dinners.

Back in June 1846, the Denzer & Stacey Company, located on Superior Avenue, sold ten thousand packets of firecrackers, imported from China, in anticipation of the Fourth of July holiday. Within the next few decades, Chinese lanterns developed into well-established Fourth of July decorations. At the other end of the cultural assimilation spectrum, the Chinese community in 1910 took part in a Cleveland Fourth of July parade. A beautifully crafted float, coupled with nearly one hundred parade members who included Chinese women riding horses, presented examples of Chinese history from 300 BC into the twentieth century.

Prominent Chinese community members enlisted female relatives who resided in other cities to perform in the Cleveland parade since the city still lacked an adequate female Chinese presence. During his San Francisco business trip, a Cleveland merchant purchased and brought back one hundred stunning costumes for use in the big event. Parade members, dressed in splendid and expensive robes of silk, carried Chinese banners and flags as they marched down Euclid Avenue. But the parade's most stunning image may have been Chinese businessman Wong Yie attired as George Washington. As part of the parade, a one-hundred-piece American band paused on Ontario Street to play the Chinese national anthem.

The Emergence of AsiaTown

Immigrants and Entrepreneurs

While Rockwell Avenue's Chinatown languished, entrepreneurs launched scattered Asian-owned restaurants, food stores and businesses directly east of downtown Cleveland. But decades earlier, the success of two restaurants, Chin's Red Dragon Café and Chung Wah, had laid the groundwork for the evolution of Cleveland's AsiaTown.

In 1918, Tong Y. Chin, a native of Canton, China, immigrated to New York. While studying commerce at New York University, Chin labored weekends at his cousin's Chinese restaurant. The education and part-time job combined to inspire Chin's lucrative culinary and business career. While still in college, Chin founded a company to prepare and deliver chow mein to lunch counter operators. Chin's clients then served a quick Chinese dish to customers who could not devote the time needed to dine in a formal restaurant.

Relocating to Cleveland in 1932, Chin cooked and delivered chow mein to restaurants, luncheonettes, hotels, schools, hospitals and drugstore lunch counters within a one-hundred-mile radius of his plant located on St. Clair Avenue near East Thirtieth Street. Putting into practice his business skills, Chin developed efficient delivery procedures incorporating sets of relay drivers to service remote locations. Within one year, he expanded his distribution operation into the residential home market. A nourishing combination of celery, onions, bean sprouts, rice and noodles, delivered to the doorstep of a Depression-era family of five, cost a total of ninety cents. Chin also founded the two-hundred-seat Red Dragon Café in the same building housing his chow mein plant.

In 1936, Chin visited China and returned to Cleveland with an eighteen-year-old wife. The Shanghai-born Wei Thung experienced challenging communication obstacles in her first years in the city. In addition to not speaking English, her Canton-born husband spoke an entirely different Chinese dialect. Wei overcame her difficulties by attending night school classes in English at Cleveland Heights High School. Her rapid Americanization even incorporated flying lessons with a local aviator. Commenting on her new life in America, Wei told reporters she especially enjoyed hot water flowing from spigots, bingo games and her husband's automobile complete with a flaming red dragon decorating the hood.

Entrepreneur Tong Y. Chin accumulated great wealth by owning restaurants and noodle and chow mein factories. *Courtesy of Cleveland Public Library, Photograph Collection.*

The couple remained married until Tong Y. Chin's death in 1975.

In the midst of the Great Depression, Chin launched a second restaurant, the Golden Dragon on Euclid Avenue near East 105th Street. During World War II, the eatery added the Victory Room, which developed into one of Cleveland's renowned nightclubs.

In 1940, a dinner visit from Palace Theater headliner Professor Quiz proved very lucrative for Jimmie Woo, a waiter at the Red Dragon. The format for the professor's radio and theater performances consisted of an unusual scheme whereby audience members asked the questions. Contestants who stumped the professor received twenty-five silver dollars. Reversing the format during his restaurant visit, Professor Quiz asked Jimmie what makes salmon swim upstream. The enlightened waiter replied, "Confucius say it must be their fins." The surprised professor concurred, handing Jimmie five silver dollars. Also that year, Chin commissioned fellow restaurateur Jessie Wong Ming to teach his Red Dragon employees the fundamentals of the English language.

In 1944, during a trip to New York, Chin recruited three former Chinese seamen to work in the Red Dragon Café. But the trio had entered the United States illegally by deserting their ship. Cleveland police received a tip that the runaways could be found working at Chin's St. Clair Avenue restaurant. During their investigation, detectives encountered a suspicious-looking padlocked door to a second-floor room. Inside, police discovered the three seamen hiding in packing boxes. Along with the hideouts, the officers arrested Chin and four of his employees on charges of conspiring to conceal and harbor illegal aliens. Later that year, Chin faced a federal investigation for allegedly obtaining and using an excess of rationed food in his restaurants. Neither event proved overly problematic. A jury acquitted Chin and his employees of the conspiracy charges while the government dropped the rationing issue.

By 1946, along with the addition of a noodle factory and a bean sprout business, Chin's $2 million enterprise produced one and a half million chow mein dinners and one million chop suey dinners. Back in 1932, Chin had started the company with two cooks and two delivery persons; fourteen years later, he employed about four hundred workers.

In 1940, Chester Chin, a native of China and cousin of Tong Y. Chin, arrived in Cleveland. Following wartime military duty, he labored in several Cleveland Chinese restaurants. Beginning in the early 1950s, Chester assisted his cousin in managing the Red Dragon. During this period, the restaurant flourished by offering good food, reasonable prices and an occasional intriguing special, such as green noodles on St. Patrick's Day. Chin prepared Thanksgiving dinners for American visitors that included roast turkey with all the trimmings ($1.45) and baked sugar-cured ham ($1.40). In 1959, customers paid $1.75 for a six-course Cantonese dinner; three extra courses cost an additional forty-five cents.

Chester purchased the Red Dragon in 1971. Six years later, he demolished the restaurant, turning the site into a parking lot to accommodate a totally new Red Dragon constructed on an adjacent lot; only the cash register survived the transformation. In 1995, Chester died at the age of seventy-one while still owning the Red Dragon. After his death, a quick succession of eating-places occupied the former Red Dragon site. The vacant building still bears yellow and red signs advertising its last tenant, Tom's Seafood.

Owner Wah Fong Wong composed and printed his own creative fortune cookie messages for his venerable Chung Wah Restaurant. "Help! I'm a prisoner in a Chinese fortune cookie factory" ranked among his customers' favorite adages. In his late teens, the native of Canton, China,

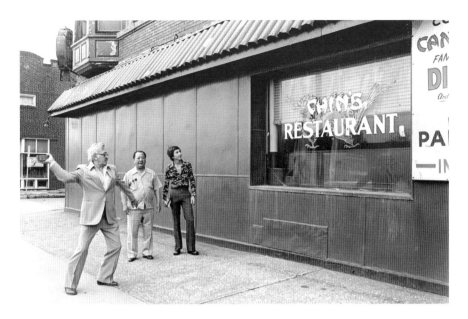

Chester Chin and his guest watched contractor Joe Bauer hurl a brick through the Red Dragon's window, a symbolic gesture to initiate the restaurant's impending demolition. The following week, a new eatery opened directly next door. *Courtesy of Special Collections, Michael Schwartz Library, Cleveland State University.*

immigrated to the United States and, in 1945, launched the Chung Wah Restaurant on Superior Avenue a block west of East Fortieth Street. In operation daily from 4:00 p.m. to 4:00 a.m., Wah promoted the restaurant as the originator of family-style Cantonese dinners in Cleveland. One of the eatery's signature dishes featured chicken liver chop suey and fried spare ribs. Photos of visiting celebrities, such as Jack Benny, Phil Harris, Gertrude Berg and others, graced the restaurant's walls. In 1978, Wah Fong died at the age of seventy-seven while visiting Hong Kong. The restaurant continued in operation into 1996. The site is now the home of Angie's Soul Café, a popular eatery offering South Carolinian fare, including chicken, pork, beef and seafood.

In the 1950s, the miniscule Asian presence in the future AsiaTown neighborhood actually declined somewhat in scope. Although the Red Dragon and Chung Wah Restaurants remained prosperous, restrictive trade laws targeting communist-ruled China severely curtailed imports. This resulted in the closing of many Chinese-oriented gift stores, including the few shops existing in what would become AsiaTown. In addition, older-style laundries had already lost their competitive edge to newer technology.

Meanwhile, children of Asian parents thrived, socially and academically, in schools located in the yet-to-be established AsiaTown neighborhood. In 1962, Chinese pupils constituted nearly one-third of the enrollment at Clara Morris Elementary School on St. Clair Avenue near East Nineteenth Street, almost every one an excellent student. About the same time, the predominately African American East High School's class of 1,500 students consisted of only a dozen Chinese members. Yet the senior class elected 1 of the 12 to the presidency of its student council.

In the 1970s, the century-old Case Elementary School, situated on East Fortieth Street, staged school-wide Asian pageants composed of skits, recorded Chinese music and the popping of balloons to simulate firecrackers. Ten students, packed into a single costume, attempted to execute an intricate dragon dance. Children of Chinese parents composed about 20 percent of the school's 440 pupils. Two generations later, bursting balloons still amuse students taking classes in a newer Case School on Superior Avenue near East Fortieth Street. But ethnic education has progressed beyond Chinese activities to also include making bread, knitting and playing the flute.

As the Red Dragon and Chung Wah faded from the city's restaurant scene, a novel food trend captured the imagination of many Clevelanders.

Bo Loong, a local pioneer in dim sum preparation, has remained a destination restaurant since its 1986 opening. *Courtesy of the author.*

Following the demise of Ontario Street's Chinatown, few, if any, Chinese restaurants in northeast Ohio served genuine Chinese cuisine. While popular among Westerners, these old-style Chinese American eateries, known as chop suey houses, sparked little enthusiasm among Asian immigrants. But in 1986, a new restaurant founded by Sin Mun (Jenny) Chan transformed Clevelanders' perception of Chinese restaurants.

In 1970, Chan emigrated from China to San Francisco. She lived on the West Coast for only a short time prior to relocating to Cleveland with her husband. After laboring as a server in a Chinese American restaurant for ten years, she founded the Silver Dragon Restaurant in Brunswick. Following the demolition of five old homes, Chan used the land to launch the Bo Loong Restaurant in a newly constructed building on St. Clair Avenue just west of East Fortieth Street. Teeming with vacant warehouses, closed industrial plants and modest homes, this portion of the street did not appear to be a likely choice for introducing a trendy restaurant. But Bo Loong has attracted both Asian and Western customers for nearly two decades.

The restaurant combines bona fide Hong Kong cuisine with twenty-two different dim sum (small portion) dishes featuring a variety of appetizers, entrees and desserts. Fresh tilapia is netted directly from the restaurant's fish tanks located near the dining area; deep-fried squab is a customer favorite. Upon request, an intriguing side order can be added to a roast duck entrée: the bird's head served on the plate. Singapore sling cocktails and Qingdao beer, imported from Tsingtao, China's second-largest brewery, are alternatives to traditional tea. Open weekends until 3:00 a.m., the hotspot hosts Asian karaoke and an occasional Chinese Elvis impersonator. In 1994, Hong Kong–born Nancy Yuen, who had been the restaurant manager since its opening, and her brother Anthony Yuen purchased the restaurant.

In the 1950s, the ten-block segment of Payne Avenue beginning at East Thirtieth Street and proceeding eastward offered no hint of its future as an Asian restaurant and shopping enclave. Jack Wong owned a retail refrigerator and radio business, and a Japanese grocery existed one block to the west. But residential homes and industries, ranging from an ice cream manufacturer to a distributor of hydraulic jacks, shared the street with very non-Asian-sounding businesses such as Mike's Bar, Sam's Diner, Myrtle's Lunch, Billy's Meat Market, Leo's Poolroom and Betty's Dry Cleaning.

In this crowded strip, David Saltzman founded Payne Avenue's Up-to-Date Fruit Market, the forerunner to the Dave's Supermarket chain. Through the market's many expansions, long-term residents have witnessed the frequent addition of new and wider doors to accommodate the growing

Beginning as a Payne Avenue fruit stand, Dave's Eagle Supermarket (photographed in 1975) has evolved into a large local grocery chain. *Courtesy of Cleveland Public Library, Photograph Collection.*

business. Adapting to their needs, the grocery store's fish department now sells tilapia caught in the wilds of China, farm-raised basa (catfish) from Vietnam, shrimp from Thailand and tiger shrimp from Indonesia.

In 1991, on this stretch of Payne Avenue, the continued popularity of Bo Loong helped inspire an event that redefined the neighborhood's history. Thirty-three years earlier, John Louie and his parents had abandoned China when the government cracked down on citizens opposing the communist ideology. Louie learned the grocery business working in his uncle's store while majoring in industrial design at Kent State University. In 1976, he founded Hall One Chinese Imports, Cleveland's first major Chinese grocery store, on Payne Avenue. Louie stocked his store with fresh food he purchased on almost weekly driving excursions to New York. Within a few years, he moved to a larger space on St. Clair Avenue, one block east of East Thirtieth Street. In addition to the retail operation, Louie expanded into the distribution business, providing Asian food to Ohio restaurants and grocery chains.

Two years after the opening of Bo Loong, Louie relocated his grocery business back to Payne Avenue to assist his proposed development of a new Asian restaurant, food market and retail-shopping complex to be situated on the northwest corner of Payne Avenue and East Thirtieth Street. According to the business plan, this initial phase would later be

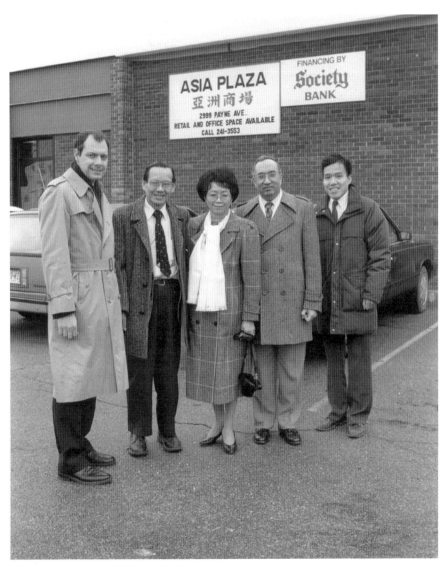

Five key people responsible for making Asia Plaza a reality are standing in front of the new mall. *From left to right*: John Kastellic (Key Bank), Willie Hom, Donna Hom, Al Rezkalla (Ohio Department of Development) and Steve Hom. *Courtesy of Steve Hom and Asia Plaza.*

Asia Plaza's 1991 debut initiated a shift in Asian presence from its previous Rockwell Avenue focal point. *Courtesy of the author.*

expanded by adding additional restaurants, offices, retail and housing, much of which would be located in a forty-five-year-old former warehouse. But Louie's ambitious Asian Village concept faltered after he failed to receive bank financing, investor support and a critical government grant. Abandoning the project, Louie sold the grocery business to Tony Ngai, a Hong Kong entrepreneur, who renamed the market Global Approach.

Donna and Willie Lee Hom, a married couple, also scrutinized Bo Loong's success. Donna, once a teacher in Hong Kong, met Youngstown-born Willie while he vacationed in China. He had earned an engineering degree from Youngstown State University; his resume included careers working for both Mahoning and Cuyahoga Counties. In 1958, Donna immigrated to Youngstown and initially toiled as a waitress, saving her tip money to establish Chinese restaurants in Rocky River and Beachwood and invest in residential and retail property.

Donna and Willie revived Louie's Asian concept on a smaller scale, in the process adding a third restaurant to their holdings. The couple knew the neighborhood very well; at the time, Donna's mother lived nearby on East Thirty-third Street. But in a slow economy, financing remained difficult to secure. Requiring an expert in finance with a background in real estate development to successfully close financial deals, the Homs looked no further than Steve Hom, their son. Steve had worked for a real estate developer while earning a degree in finance from Brown University. In the aftermath of the 1988 stock market downturn, Hom returned from New York to assist his family's development endeavor. Despite skepticism from the banking and investment community, the Hom family successfully developed the fifty-thousand-square-foot Asia Plaza mall. Willie died in 1991, the same year Asia Plaza debuted.

The mall's launching rejuvenated the Asian presence in the neighborhood just east of downtown. At the main entrance, the Li Wah Restaurant fills the western side. Non-Asian diners accustomed to Chinese American restaurants quickly identified with an extensive selection of appetizers, soups, fried rice, chow mein, chop suey, beef, pork, poultry, seafood and vegetable selections. But in accord with the trend toward more authentic Asian food, the restaurant's specialties also include conch (snails), clam, crab, squid and frog selections. More than thirty dim sum selections, served from carts wheeled throughout the dining room seven days a week, consist of beef tripe, beef balls, shrimp dumplings, steamed and roasted pork buns, steamed spare ribs, chicken feet, stuffed eggplant, taro cakes and pineapple buns.

Across from the restaurant, three gift shops specialize in decorative arts and clothing. Colorful ornamental lanterns and wind chimes dangle from ceilings as wall hangings, swords, knives, peacock feathers and decorative fans, some four feet in diameter, embellish the walls. Rows of shelves are crammed with figurines depicting dragons, frogs and zodiac animals, along with vases, bowls, dishes, glassware, tea sets, jewelry boxes, costume jewelry and purse-size Chinese fans. Ceramic, brass and jade Buddha carvings range in size from a few inches to several feet. Dramatically crafted pagodas and dragon ships sell for hundreds of dollars. Painted parasols, potted plants and bonsai in Chinese bowls complement teas, toiletries and Chinese compact discs, while small chests and tables consume available space on the floors. Children marvel at Chinese dolls and Bruce Lee toys. Very little American merchandise is sold, although brightly colored Hula-Hoops and packages of Eveready batteries are displayed.

Asia Plaza's gift shops are filled with Buddha figurines and sculptures available in a wide range of sizes, shapes and quality. *Courtesy of Danny Zhang, Flower City Gift Shop.*

Purchasing and displaying "money cat" figurines, a dependable seller in Asian gift shops, supposedly enhances the buyer's likelihood of acquiring good luck and fortune. *Courtesy of Danny Zhang, Flower City Gift Shop.*

Tommy Zhang and Becky Chu, a husband-and-wife team, immigrated to the United States in the 1980s and sold fruit on Canal Street in Manhattan's Chinatown. Tommy learned about Asia Plaza when he accidently met a childhood friend on a New York street. The friend, now working at the Good Harvest market on Payne Avenue, convinced Tommy and Becky that

Cleveland's Chinatown offered them an opportunity to succeed as shop owners. The chance meeting led to the opening of the Flower City Gift Shop in Asia Plaza. Initially lacking operating capital, Tommy purchased the store's original shelving at Walmart. Today, the successful gift shop is one of the longest-running, continuously owned stores in the mall.

Chinese immigrant Connie Zhang, the proprietor of Sister's Gift Shop, once toured major cities as a professional acrobat. Connie and her two sisters even performed at the United Nations. Coached by their father from the time they learned to walk, the three sisters learned acrobatic fundamentals passed down through many generations. In 2004, Connie retired from the grueling practice and performance demands of acrobatics to open a gift shop and dance studio. She chose Cleveland for her new vocations because of the city's warm and inviting people. All three sisters now live in northeast Ohio.

Next to the gift shops is a store specializing in traditional clothing from China and Vietnam. On display are classic cheongsam Chinese dresses originally popularized in the 1920s by Shanghai socialites. These one-piece, pure silk, body-hugging outfits, designed with Mandarin collars and

A hand-made Asian bridal gown and men's suit are part of a unique clothing collection available at the Siyan Dress Shop. *Courtesy of the author.*

slits on both sides, are now worn worldwide. At one time, Chinese wove Mandarin jackets, considered part of men's ceremonial outfits, from silk or satin brocade. Again in vogue after being out of style for decades, the jackets today are manufactured from wool but still retain their characteristic brocade pockets and frog buttons. The shop also sells handbags, slippers and shoes to accompany the dresses and jackets.

Down the hall and to the right is the Siyan Dress Shop, providing custom-made wedding dresses, men's and women's suits, apparel accessories and tailoring and alterations. In a unique example of diversity, the store also stocks the latest Asian videos and compact discs.

Besides gift and clothing stores, other Asia Plaza tenants offer a variety of services. When the mall opened, Phillip Yee resigned from his job as a flight attendant to establish the Imperial Travel Agency. In 1996, MetroHealth developed a satellite clinic on the plaza's second floor. Eight staff members speak fluently in several Chinese dialects. Steven Sok, a Vietnamese emigrant living in California, relocated to Cleveland to establish the Angkor Jewelry shop, specializing in higher-end imported gold and jade merchandise along with costume jewelry. The World Financial Group offers the Asian community investment planning services and assistance in filling out federal, state and city tax returns. A nail salon caters to Asian clientele.

Beginning in 1996, the Cleveland Housing Network has occupied space in Asia Plaza. The once relatively small organization has developed into northeast Ohio's largest community development association. The current multicultural staff of 130 people utilizes space on all three floors of the plaza. In addition to a unique mixture of stores, services and office tenants, the mall sponsors senior health fairs and cooking classes and contests.

The success of these Asian restaurants and shops inspired community leaders to improve housing alternatives. An immediately indentified need focused on providing accommodations for older Asians living in the neighborhood. In 1998, the five-story, forty-three-unit Asian Evergreen retirement apartments debuted to great fanfare on Payne Avenue. Sponsored by the Cleveland Chinese Senior Citizens Association and constructed by HUD, the new apartment building helped Asian seniors escape from their former lonely, cramped and often unhealthy living conditions.

A few blocks west of the new apartments, the Chinese Christian Church conducts Sunday services at 9:30 a.m. and 11:00 a.m., the first in the Mandarin language and the second for Cantonese-speaking Christians. In 2002, the church expanded by constructing a new building while retaining its old home, a former residential house now attached to the newer structure. In

addition to religious services, the church sponsors health fairs and conducts classes to explain practical aspects of American culture, such as the definition and purpose of a certificate of deposit.

From Tong Y. Chin's 1930s chow mein empire to the Chinese Christian Church's services in the twenty-first century, this growth in Asian restaurants, markets, shops and organizations has taken place in a segment of Cleveland bordered by Chester Avenue (south), St. Clair Avenue (north), East Eighteenth Street (west) and East Fifty-fifth Street (east). Neighborhood leaders recognized the Asian influence extended beyond China and, in 2007, rebranded this region as Cleveland's AsiaTown.

8

AsiaTown Today

Twenty-First-Century Diversity

Attracted by the proximity to good-paying factory jobs, Eastern European immigrants once lived and raised their children in a neighborhood that is now a multiracial, mixed-use district remarkably rich in racial, economic, cultural and architectural diversity. Asians share the neighborhood with Slovenians, Lithuanians, Croatians, Poles, Slovaks and Germans who still reside in a locality now luring newcomers from Ethiopia and Puerto Rico, as well as Asia. Chinese constitute the majority of the Asian population, but Vietnamese, Japanese, Korean, Indian, Filipino and Cambodian immigrants have also purchased or rented homes in the district.

Asian-oriented restaurants, food markets and specialty shops coexist on main roads with former industrial sites, some abandoned eyesores and others smartly renovated into live-work lofts appealing to artists and smaller companies. The city has rehabilitated many of the major streets, while the Economic Development Department offers matching grants to retailers who enhance the street presence. Frank Jackson, Cleveland's mayor, has taken walking tours to view the neighborhood's newfound progress and vitality. Businesses entice Asians from across northeast Ohio and beyond, along with adventurous non-Asians who have discovered the allure of bubble tea, congee, pho, larb and bibimbap.

On smaller side streets, Asian families join other ethnic groups who live in century-old homes, some newly renovated. Front yards, beautified by flower gardens, also exhibit an occasional tomato or melon plant. Vegetables and herbs are grown in side and backyards; the harvest is sold to markets and

Asians, along with many other nationality groups, reside in homes located on AsiaTown's numerous side streets. *Courtesy of the author.*

restaurants, as well as used in family cooking. Reminiscent of many Cleveland neighborhoods a half century ago, mothers trust the safety of their ten-year-old daughters as the children walk to and from Saturday dancing classes or run errands to a nearby grocery store or market. For Sale and For Rent signs are noticeably absent from streets dedicated to housing.

Attesting to the region's beguiling and occasionally quirky diversity, a now-defunct auto parts store on Superior Avenue supposedly introduced bubble tea to northeast Ohio. This cold Taiwanese beverage is a mixture of tea, ice and condensed milk, combined with small pearl-like balls of cassava root (tapioca) or yam starch. The curious concoction is chewed as well as sipped.

Uncommon cultural amalgamations seem to flourish in AsiaTown. In 1983, the husband-and-wife team of Jim and Bok Hun immigrated to Cleveland from Seoul, where Jim had owned a printing business. The couple acquired expertise in pizza preparation while working at a St. Clair Avenue pizza shop owned by Jim's sister and then founded Royal Pizza II in Lakewood. In 1985, Jim and Bok transformed an old Payne Avenue coffee shop into the very nontraditional de Angelo's Pizza and Korean Restaurant. While selling pizza downstairs, the creative pair added an upstairs room to

Debuting in 2008, the 115,000-square-foot Asian Town Center mall is situated on Superior Avenue at East Thirty-eighth Street. *Courtesy of the author.*

serve stir-fried squid and other Korean specialties. The site, later housing the Seoul Hot Spot Restaurant, is now vacant.

In late 2008, the expanding neighborhood welcomed a new landmark as the first wave of tenants populated Asian Town Center, a four-acre, 115,000-square-foot enclosed mall constructed in an abandoned eighty-eight-year-old lighting factory. Anchored by two restaurants and a grocery store, other tenants include a beauty supply store, an herbal store, a daycare center, an art gallery and café, a martial arts center, a Japanese drumming school and service-oriented businesses providing massages, travel assistance and income tax preparation.

Construction of Asian Town Center and the earlier Evergreen apartments both incorporated principles of feng shui, a philosophical methodology created to harmonize human living with the surrounding environment. The overall objective is to create beauty and harmony while expelling negativity. Closely related to yin and yang beliefs, feng shui concepts influence interior and exterior color and landscaping, the arrangement of furniture and art objects and the placement of doors, windows, hallways and staircases. Design of the Asian Evergreen apartments promoted comfortable living while prosperity and success guided the motif of Asian Town Center.

Cutting-edge Asian restaurants remain the centerpiece attraction for visitors to AsiaTown. As the Food Network and other cable programs exposed Westerners to Asian cooking, a new generation of restaurant owners eagerly welcomed non-Asians to their traditional or contemporary-designed eateries offering genuine Asian cuisines.

Three newer Chinese eating-places (Won Ton Gourmet, Szechuan and Emperor's Palace) have joined AsiaTown's groundbreaking Bo Loong and LiWah Restaurants. Won Ton Gourmet caters to almost every Chinese culinary taste; owner Thomas Tam even created three different menus: Hong Kong style, authentic Cantonese and Americanized Chinese. The restaurant's walls are filled with supersized full-color pictures of the eatery's food offerings, along with identifying numbers to simplify the ordering process, eliminating the need to consult any of the trio of menus.

Food prepared with chili peppers, Sichuan peppercorn berries and other spicy herbs and plants is never bland. Szechuan Restaurant embraces the spicy Szechuan cuisine that originated in Sichuan, a province of southwestern China. The beautiful Emperor's Palace, located in Rockwell Avenue's Historic Chinatown area, is the most recent AsiaTown restaurant devoted to Chinese cuisine.

To varying degrees, devotees of Chinese American food will discover their favorite selections at all five restaurants. But authentic Chinese dishes entice the majority of diners to AsiaTown. Congee, a versatile thick rice soup similar to porridge, can be ordered plain as a breakfast treat or combined with chicken, beef, pork, duck or seafood as a lunch or dinner selection. Along with their congee, early morning customers enjoy televised Chinese newscasts. Diners in groups gravitate to restaurants offering "hot pot" and "dry pot" selections. Resembling fondue, a hot pot meal begins with spicy broth simmering in a metal container, which is placed in the middle of the dining table. Each diner chooses his or her favorite sliced meats and vegetables, cooks the selections in the broth and finally dips the cooked food into an assortment of hot sauces. Dry pots eliminate the broth and individualized cooking but retain the added spicy flavoring. Diners concur on five types of meat (beef, lamb, chicken, rabbit or pork) or a selection of fish, as well as five vegetables, all of which are mixed by the chef and served in a communal pot. More daring visitors select dumplings filled with crab meat as appetizers and dinners featuring stir-fried or baked frog, a whole fish fried with fermented bean sauce or spicy pork intestine soup.

Toward the end of the Vietnam War and afterward, about 1 million South Vietnamese citizens immigrated to the United States. By 1990, only

702 of them had found their way to Cleveland, most of them living in the Detroit-Shoreway neighborhood west of downtown. Through the years, the city has attracted more Vietnamese immigrants, along with students and business visitors.

Although few Vietnamese reside in AsiaTown, a section of Superior Avenue near East Thirtieth Street is home to four popular Vietnamese restaurants: Superior Pho, #1 Pho, Saigon Grille and Ninh Kieu. Pho, a Vietnamese staple, is spicy noodle soup. Restaurants differentiate themselves by the taste of the broth and the variety and quality of the noodles, meat and extra ingredients. The versatile soup can be an appetizer, lunch treat or full-course meal, depending on its size and content.

In 2002, Saigon immigrant Manh Nguyen, a Cleveland resident since 1975 and a former metallurgist, opened Superior Pho Restaurant. Located down a hall and in the back of a moderately dreary building where Superior Avenue intersects East Thirtieth Street, Superior Pho is advertised as Cleveland's first Vietnamese restaurant dedicated to pho. Despite the somewhat out-of-the-way location, restaurant customers consume about five hundred quarts of pho each day. No more than six months after Superior Pho's debut, Vietnam natives

The trendy Saigon Grille specializes in Vietnamese and Thai food. *Courtesy of the author.*

Danny Nguyen and Ken Ho, who met in Philadelphia, unveiled #1 Pho. The restaurant quickly established itself as a destination eatery specializing in noodle soup, rice dishes and vegetarian selections.

Saigon Grille, just a block east of Superior Pho and #1 Pho, is located in an old warehouse now decorated in modern Asian-fusion décor. Farther east on Superior Avenue, the Ninh Kieu Restaurant is situated on the second floor of Asian Town Center. Here, pho selections are served with five choices of beef—round steak, brisket, flank, tripe and soft tendon. Choosing among the five beef options is not necessary; Pho Ninh Kieu Dac Biet combines noodle soup with a sample from each of the five cuts of beef.

Koreans entered the United States in small numbers over a long time period. Because of strict immigration policies, many of them arrived possessing already established professional backgrounds, often in engineering, science and healthcare. Their gradual entrance did not foster close-knit residential communities; instead, Koreans settled in scattered suburban communities. Few made their homes in AsiaTown, but the country's cooking is personified in the menus of three Superior Avenue restaurants: Korea House, Ha Ahn and Miega.

In 1979, Korea House chef Sin Bae Kang and owner Chul Y. Kim tested their marinated beef short ribs. *Courtesy of Special Collections, Michael Schwartz Library, Cleveland State University.*

Korean cuisine features beef, pork, short ribs, fish, shrimp and chicken teriyaki. Among the more exotic dishes are Bibimbap (a bowl of rice topped with vegetables, beef and a fried egg), Dae Goo Muh Ri Jjim (a catfish head braised in a spicy sauce) and Ojingabokkum (stir-fried squid with vegetables).

Korea House, the grandfather of the district's Asian restaurants, made its debut on Payne Avenue in 1978. Originally housing only twelve tables, the restaurant in 1991 relocated to its current Superior Avenue site. Typical of Korean eateries, Korea House engages its customers in the food preparation process. Equipped with a tabletop hot plate and flat skillet, guests complete the preparation of many entrees. At Ha Ahn, tofu soup is served complete with an egg, which the customer cracks into the bowl. This diminutive but friendly Korean restaurant, owned by Korean immigrant Stella Lee, is almost hidden in an old building sitting on the corner of Superior Avenue and East Thirtieth Street.

Family and friends encouraged Jung Chang, another native of Korea, to open the Miega Korean Barbeque after she had spent forty years cooking delicious dinners as a housewife. A small gas stove is included to ensure dinners are cooked to customers' specifications. Every table contains an electronic call button to alert servers that their assistance is desired. While dining, patrons enjoy a flat-screen television tuned in to Korean music videos, soap operas and newscasts. About half of Miega's customers are Chinese, while another 20 percent are Korean. But Cleveland's non-Asian suburbanites are also well represented. A Bay Village couple, who once regularly frequented Brooklyn's massive Chinatown, now makes periodic trips to AsiaTown's markets and restaurants, including Miega. The couple noted Cleveland offers much of the same grocery selections and dining experiences found in New York, although on a much smaller scale.

Two AsiaTown restaurants, Siam Café and Map of Thailand, cater to customers who enjoy Thai cooking. In 1994, a former Red Barn Restaurant resurfaced as the remodeled Siam Café. An elegant etched-glass divider partitions the dining area, converting the smaller portion into an intimate setting. About one hundred Japanese lanterns, in various sizes, hang from the ceiling to subtly promote Tsingtao beer imported from China. Connoisseurs of beer also select imports from Thailand, Japan, Holland, Mexico, the United Kingdom, Germany and Ireland. For more traditional American tastes, Bud Light is also readily available.

An extensive menu allows members of large groups, with varying individual tastes, to choose multiple main selections while sampling less

The Red Barn Restaurant site, photographed in 1976, eventually housed the Siam Café. *Courtesy of Special Collections, Michael Schwartz Library, Cleveland State University.*

familiar dishes. Large, round tables and lazy Susans encourage sharing dishes. Tanks sometimes containing tilapia, lobster, crab, catfish, eel and frogs can be viewed as an amusement or as a means of selecting a dinner dish. Unlike the majority of Asian restaurants, Siam Café's creative dessert

The chic Siam Café's menu unites cuisines from Thailand, China and Vietnam. *Courtesy of the author.*

Payne Commons, a small strip mall, houses the Map of Thailand Restaurant and KoKo Bakery. *Courtesy of the author.*

menu incorporates Black Forest cake, New York cheese cake and molten chocolate cake.

In 2011, four former employees of Mint Café, a Cleveland Heights restaurant located on Coventry Road, launched Map of Thailand. The restaurant's specialties include larb, a sautéed shredded chicken salad mixed with onions, mint, lemon grass, roasted rice powder, chilies and lime. Diners seeking an out-of-the-ordinary meal opt for Andaman Princess or Full Moon Party; both dishes contain a mixture of shrimp, squid, mussels and scallops.

Since traditional Thai dishes often originated in neighboring countries, Thai restaurants often combine interrelated cuisines from Thailand, China and Vietnam. Soup selections, an obvious illustration of the blending of nearby cultures, embrace China's ubiquitous wonton, Thailand's Tom Yum Goong (shrimp) and the Vietnamese Tok Kar Gai (chicken soup with coconut milk).

The East Thirtieth Street Café, one of the most eclectic eateries in the city, debuted in Asia Plaza in 2010. The café serves delicacies adapted from Chinese, Korean, Vietnamese, Japanese, Thai and United States cuisines—sushi, dim sum, a baby octopus salad, eel dragon roll (shrimp and crab meat topped with a taste of eel), jade roll (salmon skin, cucumber, apple and mango covered with white and seared tuna) and caterpillar roll, which actually contains eel, cucumber and avocado. Customers with hardcore American tastes can select from New England clam chowder, Maine lobster, Italian minestrone vegetable soup or even an American burger.

In developing their menus, Asian chefs often integrate yin and yang principles. Foods associated with yin are bean sprouts, beets, cabbage, carrots, blackberries, raspberries, cucumber, watercress, crab and duck. Yang foods are chicken, beef, eggs, bamboo, ginger, mushrooms and sesame oil. Sweetness usually implies yin while saltiness is allied with yang. Ying foods are prepared by boiling or steaming; yang dishes are stir-fried or roasted. The balancing of yin and yang creates combinations such as beef and broccoli. Cholesterol-laden shrimp is often paired with berries, known for their ability to reduce cholesterol.

The neighborhood's food markets appeal to Asians from Cleveland, its suburbs, Akron, Youngstown and as far as Pittsburgh and Erie. Owned by Duc Tran and his wife, King Chung, the thirteen-thousand-square-foot Tink Holl anchored Asia Plaza prior to the market's 2005 relocation to East Thirty-sixth Street. Shelves are stocked with noodles in a vast variety of sizes, shapes and ingredient combinations. Imports comprise rice from Thailand, fruits and vegetables from Indonesia and tea from Japan. The market sells

fresh seafood, including eel and shark; a large variety of spices and sauces; fifty-pound bags of rice; and red bean ice cream balls.

The Asia Food Inc., now an anchor of Asian Town Center, relocated from its former twenty-year home on St. Clair Avenue. Eric Duong and Michael Hong, brothers and refugees from Vietnam, founded the market in 1988. The grocery selection incorporates spices from China, beans from India, sausage from the Philippines, curry and green eggplant from Thailand and other imported food from Vietnam, Laos, Korea, Japan and Indonesia. A frozen food section displays squid, clams and mussels. More exotic offerings include edible chrysanthemum leaves and balut, a delicacy composed of a developing duck embryo. Professional Asian chefs and amateur cooks explore aisles filled with teas, noodles, spices, opo squash, fresh lotus root, bamboo leaves, green papaya and Shi-Li-Hon (snow cabbage). A bakery, deli, barbecue area, prepared food section, café serving pho and dining section are integrated into the market. While incorporating modern supermarket design, the market intentionally retained part of the industrial look of its former tenant.

Gary Chen, a former restaurant owner, founded Park To Shop, a grocery store anchor attached to Asia Plaza, partly because of his frustration in obtaining authentic Asian food. Chen's entrance into the grocery business

The modern Park To Shop grocery store is one of the largest Asian markets in Ohio. *Courtesy of the author.*

coincided with the demise of the Topps supermarket chain in the northeast Ohio market and the closing of several Giant Eagle stores. These shuttered stores enabled Chen to purchase expensive equipment at bargain prices. Advertised as Ohio's largest Asian supermarket, the modern-looking market is noted for a huge variety of noodles stocked in a special room and a large aisle devoted exclusively to soy sauce. The store offers a wide selection of alternative meat products (such as tofu steak and vegan meatballs) and seafood substitutes (tofu, chickpeas and sea vegetables).

At first glance, Koko Bakery on Payne Avenue bears a resemblance to its conventional American counterparts. Brownies, chocolate chip cookies and strawberry cakes seem to fill the inviting bakery's glass cases. But treat lovers seeking more unusual indulgences savor pieces of Mandarin orange cake or a bright purple pastry filled with a small duck egg. Taro, beef curry and pineapple-flavored bolo typify the variety of available breads. Snacks consist of salad bowls, soups and buns filled with fruits, vegetables and meats. Customer favorites are pork buns (either manapua or char siu babo) and low po beng (a melon bun). Dessert devotees enjoy Taiwanese and Korean shaved ice and a variety of smoothies. In addition to hot tea and coffee, beverage selections include soymilk, bubble tea and Hong Kong tea composed of black tea and condensed milk.

AsiaTown herbalists and herbal stores work together to offer diagnostic services, medication and treatment. The seemingly ever-present principles of yin and yang partly govern the selection of food and herbs employed in Asian medical treatment. The philosophy implies an illness can be cured by relying on food consumption rather than antibiotics or other commercially produced medicines. A human organ containing an overabundance of yin will bring about a slowdown in physical metabolism, while too much yang leads to a comparable acceleration. A yin-natured illness requires consumption of food associated with yang and vice versa.

Imbalances between yin and yang are created by four situations: too much yin, too much yang, not enough yin or not enough yang. A diner incurring heartburn caused by consuming too much spicy (yang) food might drink herbal tea to restore yin to the body. The remedy for curing a cough could be centered on increasing yang, thereby counteracting the yin that created the cold. But a patient suffering from dryness might be advised to increase yin since too much yang is believed to have generated the discomfort. Consumption of watercress might be recommended to remove excess yang. Other foods are used to simultaneously balance yin and yang consumption; one example is dried duck gizzards. Ginger heats the body, while chili pepper

acts as an expectorant to assist in removing viruses. Other ingredients soothe the throat or even make unique blends of herbs easier to drink.

Based on centuries of experience, some foods are associated with specific health problems. Gastrodia, a mushroom feeding from soil fungus, is used to control hypertension, improve circulation, alleviate headaches and enhance memory. Prescriptions for patients desiring weight loss might include green tea (which burns fat), fennel (an appetite suppressor), licorice (which retains blood sugar and consequently reduces craving for sweets) and aloe vera for improved digestion.

Hilton Tam, once head of the property loan department of a Hong Kong bank, also owned an Asian herbal medicine store. In 1991, fearing the consequences of China's takeover of Hong Kong, Tam and his wife, Angela, immigrated to the United States and founded an herbal store in Asia Plaza. After an examination, Tam prescribed a custom-designed combination of herbs, each with its own purpose, to create proper balance in the body. These concoctions are most effective when combined with diet and qigong, a combination of breathing exercise, meditation and alternative medicine, all part of Tam's consultative services. Tam later retired and returned to China, where he died. Tak Yuen Tong, a second herbal store in Asia Plaza, is owned by Dr. So Chan. One satisfied patient claimed her upper respiratory infection persisted for months using Western remedies but disappeared after two days of consuming the herbal tea and all-natural cough syrup prescribed by the doctor.

Dr. Yinhai Zhu, educated and trained at the Zhejiang Chinese Medicine University, practiced medicine in China for three decades prior to founding the Bai Wei Herbal Store on St. Clair Avenue. In Dr. Zhu's current location in Asian Town Center, the waiting room often contains a diverse group of patients discussing their success stories in using herbal remedies. One morning, a teacher living on Cleveland's west side and a retired restaurant owner from suburban Mentor compared their experiences using chrysanthemum tea to improve their eyesight. The nearby Tong Health Food Store carries an ample supply of teas, herbs, extracts, nuts, juice, pills and Alaskan deep-sea fish oil.

In addition to the Flower City Gift Shop in Asia Plaza, Tommy Zhang operates the Jet Shing Tong herbal store located a few blocks north on Superior Avenue. Tommy acquired an understanding of Asian healing concepts at an early age. As a member of the Shaolin Temple in China, his father practiced an integrated approach to healthy living comprising natural foods, exercise and meditation. Consulting with customers in China

Christopher Dillon's *Serpentes the Sorcerer* aroused the curiosity of customers entering Asian Town Center throughout the 2013 Year of the Snake celebration. *Courtesy of the author.*

since the middle of the twentieth century, his reputation spread to America and Europe. Beginning at the age of twelve, Tommy received hands-on experience assisting his father. Tommy and two brothers now manage Jet Shing Tong (the three brothers' Chinese names) stores in Los Angeles and San Francisco, as well as Cleveland's AsiaTown location.

Each year since 2006, the Saint Clair Superior Development Corporation and local businesses have sponsored a public art project to advance awareness of the AsiaTown neighborhood. Northeast Ohio artists design about twenty-five fiberglass sculptures that represent the zodiac animal for that year. The sculptures are displayed throughout the neighborhood during the summer and then auctioned in the fall.

In 2010, the growth of AsiaTown inspired its leaders to promote the neighborhood to the entire northeast Ohio community. Stakeholders created a one-day street festival to showcase AsiaTown's attractions and redevelopment. About ten thousand curious people journeyed to Payne Avenue and nearby parking lots to take part in the initial event. The next year, backers expanded the festival to two days. In the third year, the turnout climbed to more than forty thousand people.

Greater Clevelanders sampled choice Asian food from nearby restaurants, inspected merchandise sold by local businesses, participated in egg roll and

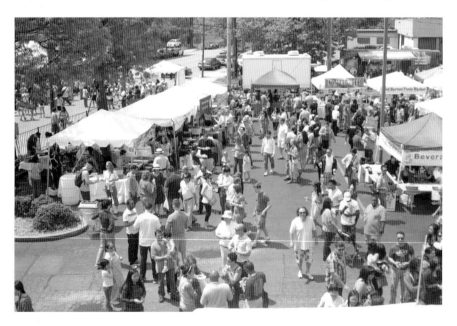

Between forty and fifty thousand visitors attend the annual Cleveland Asian Festival in the AsiaTown neighborhood. *Courtesy of Cleveland Asian Festival and Le Su.*

Neighborhood residents, festival performers and Greater Clevelanders from the city and suburbs inspect clothing offered by a festival vendor. *Courtesy of the Cleveland Asian Festival and Trish Uveges.*

sushi eating contests, battled inflatable sumo wrestlers, witnessed martial arts demonstrations and gathered information from community organizations. Two stages provided the settings for music and dance demonstrations, along with fashion shows featuring contemporary and historic Asian clothing. The Kwan lion dance team periodically roamed through the festival presenting lively twenty-minute demonstrations.

The festivals have also featured appearances by well-known entertainers: actress Yin Chang (famous for her part in the Disney film *Prom* and a reoccurring role on television's *Gossip Girl*); Dat Phan, a Saigon-born Asian stand-up comedian and original winner of the *Last Comic Standing* reality show; Instant Noodles (a Taiwanese dance team from California); and Cheesa Laureta, star of the second season of *The Voice*.

Near the end of 2013, AsiaTown stakeholders completed a master plan to ensure that the neighborhood's development and momentum is continued.

During public meetings conducted in English, Mandarin and Cantonese, residents offered their reactions to the ideas, concepts and drawings that eventually composed the master plan. As AsiaTown continues to grow, additional restaurants are in the planning stages, as are new methods to engage residents and attract visitors to this very unique Cleveland neighborhood.

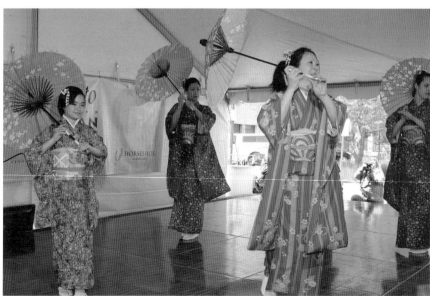

Reflecting the diversity of the AsiaTown neighborhood, Cleveland Asian Festival performers represent a wide variety of nationalities and ethnic groups. *Courtesy of the Cleveland Asian Festival and Harry Weller.*

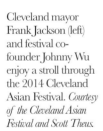

Cleveland mayor Frank Jackson (left) and festival co-founder Johnny Wu enjoy a stroll through the 2014 Cleveland Asian Festival. *Courtesy of the Cleveland Asian Festival and Scott Theus.*

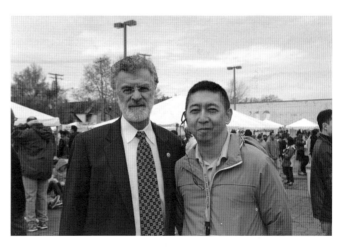

Opposite, top: Children (and adults) enjoy participating in challenging chess matches hosted by the Cleveland Asian Festival. *Courtesy of the Cleveland Asian Festival and Harry Weller.*

Opposite, bottom: Dance groups, whose members embody a wide range of ages, demonstrate traditional Asian dance performances on two stages at the Cleveland Asian Festival. *Courtesy of the Cleveland Asian Festival and Harry Weller.*

A dragon paraded through AsiaTown will soon appear to come to life as a professional dance team performs an eagerly anticipated dragon dance at the 2014 Cleveland Asian Festival. *Courtesy of the Cleveland Asian Festival and Darlene Beiter.*

Asian cuisine, represented each year by about twenty-five local restaurants, is a perennial highlight of the Cleveland Asian Festival. *Courtesy of the Cleveland Asian Festival and Donna Schneider.*

The Cleveland Asian Festival's food and cultural events attract about forty thousand people each year who represent a broad mixture of ages and ethnic groups. *Courtesy of the Cleveland Asian Festival and Donna Schneider.*

Crowds enjoying the Cleveland Asian Festival are treated to entertainment provided by nationally known performers and these possible up-and-coming superstars. *Courtesy of the Cleveland Asian Festival and Trish Uveges.*

Japanese Taiko drummers entertain visitors at the 2014 Asian Festival. *Courtesy of the Cleveland Asian Festival and Donna Schneider.*

Index

Index

Index

Index

Index

About the Author

Native Clevelander Alan Dutka is a retired executive. During his business career, he authored four marketing research books, including *Customer Satisfaction Research*, a primary selection of the Newbridge Executive Book Club that has been translated into Spanish and Japanese editions. Since his retirement, he has published four other Cleveland history books: *Cleveland Calamities: A History of Storm, Fire and Pestilence*; *East Fourth Street: The Rise, Decline and Rebirth of an Urban Cleveland Street*; *Cleveland's Short Vincent: The Theatrical Grill and Its Notorious Neighbors*; and *Cleveland in the Gilded Age: A Stroll Down Millionaires' Row* (coauthored with Dan Ruminski). Dutka is a popular speaker at historical societies, libraries and community centers.

Visit us at
www.historypress.net

..

This title is also available as an e-book